HIDDEN HISTORY
of the
FINGER LAKES

HIDDEN HISTORY
of the
FINGER LAKES

Patti Unvericht

Published by The History Press
Charleston, SC
www.historypress.com

Copyright © 2018 by Patricia Unvericht
All rights reserved

The Kirkbride main building was constructed in 1866 and demolished in 1980.

First published 2018

Manufactured in the United States

ISBN 9781467138192

Library of Congress Control Number: 2018936076

Notice: The information in this book is true and complete to the best of our knowledge. It is offered without guarantee on the part of the author or The History Press. The author and The History Press disclaim all liability in connection with the use of this book.

All rights reserved. No part of this book may be reproduced or transmitted in any form whatsoever without prior written permission from the publisher except in the case of brief quotations embodied in critical articles and reviews.

This book is dedicated to Steve, who gave me the inspiration and encouragement to keep going and live life with no regrets. And to my children, Liesl and Karl, who are my co-pilots on many adventures.

Contents

1. Andover Sanitarium — 9
2. Cracked Wheat and Granula — 18
3. Daredevils — 29
4. Devil's Nose — 39
5. DeWitt Clinton Guy — 42
6. Hamlin CCC Camp/POW Camp — 45
7. The Loomis Gang — 50
8. Birthplace of Memorial Day — 56
9. Murder of Crows — 60
10. National Exchange — 62
11. Onondaga — 66
12. Rochester Orphan Asylum Fire — 73
13. Rochester Ripper — 78
14. Rod Serling — 82
15. Rose Lummis — 85
16. Scythe Tree — 91
17. Brockport Soldier Tower — 93
18. Troutburg — 96
19. Two Foxes and the Devil — 101
20. Willard — 106

Bibliography — 117
About the Author — 125

I
Andover Sanitarium

Take a drive south on Route 21 through the rolling hills of Allegany County. The countryside is beautiful any time of the year, but during the autumn months, it puts on its best show. The air is crisp and clean as the sinking sun shines through amber leaves that glow as if they have been set on fire. As you crest the hill just north of the town of Andover, a breathtaking sight hits you. Pure-white church steeples peek through the fall foliage, welcoming visitors to their sleepy little town. With a history that spans over two centuries, Andover was once very much alive.

Who the first settler was in Andover is up for debate. Two men claimed the right to be called founder. Nathaniel Dike came to the area first, in 1795, but in 1807, Alpheus Baker was the first to settle in what is now the town center. Baker and Dike, as did other pioneers, blazed a trail west after the American Revolution so that others might follow them into what was the unknown wilderness. Towns like Andover sprouted up all over the place, and they flourished. For more than a century, Andover prospered. Businesses thrived, and small factories and processing plants supported the community. Although these small towns thrived in the nineteenth century, they all soon fell by the same sword, industrialization and modernization. What were once centers of commerce became bedroom communities, and their residents looked for employment in larger neighboring cities. Buildings and storefronts emptied and were abandoned, leaving behind shells of their former lives, memories of a more prosperous time. Each town had buildings that were more important

to the town's history than others and citizens that embodied their spirit. The Victorian building affectionately known as the Brick—located at 5 West Greenwood Street—and the couple who were its most prestigious owners played prominent roles in Andover's history.

The first burial ground in Andover was on "John Goodwin's lot," according to history.rays-place.com. Goodwin's property was on Main Street, with the portion of his lot with the cemetery in what is now the backyard of the Brick. There were only a few interments in the cemetery, some of the very early deaths in the town prior to 1825. Those who were laid to rest there included the children of the town founders Alpheus Baker, James Woodruff, Luther Strong and Benjamin Brookins. It was also the final resting places of Mr. Lyons and Mrs. Lovell as well. The graves are still there, buried deep in the ground, but they have no stones to mark them. To those unaware of its existence, the cemetery is indiscernible.

The earliest known map of Andover with the West Greenwood property listed, along with its owner's name, is from 1856. It was the location of Martindale Carriages, which was owned by William and Eliza Martindale. William died in 1868, followed by his wife four years later. After their deaths, no record shows what happened to the carriage shop. Devastating fires plagued towns during that time; wooden buildings tended to quickly go up in smoke, especially when fire was used to tame iron, like at a blacksmith shop or by a carriage maker. It's possible that was the fate of Martindale's shop, because the lot was empty when the next owner bought it in 1876. The building that was then erected has an interesting and important history that is almost forgotten today.

While the Martindales were still alive, Dr. William Crandall resided on Elmwood Street. He came to Andover in 1858 and joined the practice of Dr. John Harmon. Dr. Harmon retired from the medical field to go into private banking and left his practice to Crandall. Sometime in 1876, Crandall acquired the property once owned by William and Eliza Martindale. He soon began building his grand home, or rather, the original structure Crandall had built went up in 1876. Before the good doctor could move in, the house was destroyed by a fire. All accounts and investigative reports of the fire point to the cause being "incendiary in origin," meaning it was criminally set by an arsonist. Either it was set by someone with a personal vendetta against Dr. Crandall or by Crandall himself because of financial problems. There are rumors that support both theories. Regardless of the actual cause of the fire, Dr. Crandall rebuilt it as a beautiful, three-story brick building that stands there today, the Brick.

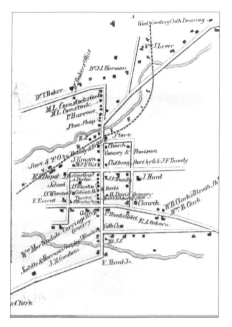

An 1856 map of Andover, originally published as part of a larger map of Allegany County by Gillette, Matthews & Company. *Allegany County Historical Society.*

Crandall was by far more educated than most small-town doctors of his time; he also was quite the humanitarian. It is said that he hardly ever charged the very poor for his services, and they received only the very best care. Dr. William W. Crandall died on March 19, 1899, in the nearby town of Wellsville. He is buried at the Alfred Rural Cemetery in Alfred, New York (alleganyhistory.org).

After Crandall's death, Daniel B. Spaulding purchased the Brick and turned it into his home. D.B. Spaulding was born in September 1820 in New Marlboro, Massachusetts. Early in his life, both he and his father were farmers. After Spaulding married Phebe Barton in 1850, they moved to New Hudson, New York, which is in the western portion of Allegany County, to find work in the lumber industry. He did whatever jobs necessary to provide for his family. It was not until 1867 that he and his family moved to Andover. By then, Spaulding was trying his hand as a businessman, dabbling in different ventures until he finally settled on running a drugstore. Daniel B. Spaulding died on August 30, 1906, and was laid to rest at the Valley Brook Cemetery in Andover.

Spaulding owned the Brick for only one year before the Egglestons bought it from him. They were the ones who gave the building life and were the most important of its owners. After they purchased the home, it reverted to the role of serving the community and those in need as a sanitarium.

Hattie Borden Eggleston was born on December 13, 1872, in Norwich, Connecticut. When she was a child, she was sickly. A disease or some other ailment left Hattie paralyzed. Her family was told that she would never walk again. Hattie did not like the prognosis that she was given by the doctors. It was only through strength and sheer determination that she was able to overcome her disabilities three years later. By nature, Hattie had a nurturing personality. It only made sense that she enrolled in a New York City nursing school and graduated first in her class and was the first to receive her white cap. After graduation, she met Vernon Eggleston. On December 8, 1897, they were united in marriage. Shortly after the wedding, they moved to Andover (1897–98), where Vernon became the preacher for the First Baptist Church.

When the sanitarium opened, Hattie naturally followed her instincts and recalled her education as a nurse. She truly cared for her neighbors and for those who sought out her help. The sanitarium was a family affair. Vernon was not only the preacher of a local church—he also managed the business end of the sanitarium. As if that was not enough, Vernon also joined local druggist James Chessman in a pharmaceutical business.

The world around them was changing. Conflict raged in Europe, and World War I broke out. President Wilson tried his best to keep the United States out of the war, but after a series of events, the decision to be neutral was no longer feasible. When the United States finally joined our allies on the battlefield in 1917, Vernon felt compelled to do his part and enlisted through the YMCA (Young Men's Christian Association) as a man of the cloth. He was assigned to the front lines in France, where he helped carry the dead and wounded off the battlefield. Vernon witnessed up close the horrors of war. He was in the thick of things, constantly in danger. Eventually, he was wounded himself. He also contracted Vasquez Disease, a rare form of cancer affecting red blood cells and bone marrow.

While her husband served his country overseas, Hattie took care of her community at home. When Vernon returned home from the war, he continued to serve with the YMCA. He was sent to different locations all over the Western Hemisphere as a secretary. Hattie had enough of being separated from Vernon when he was thousands of miles away on the front lines. She sold the sanitarium and traveled with Vernon all across the country and in Central America. While in California, complication with his cancer forced Vernon to his bed. After being confined to a sickbed for thirteen months, Vernon lost his battle and passed away in

1922. Brokenhearted and homesick, Hattie brought Vernon's ashes back to their home in the Allegheny foothills.

The following obituary was published in the *Andover News* after his death:

> *Rev. V.L. Eggleston*
>
> *Memorial services for the late Rev. VL Eggleston AM were held at the Baptist Church in this village, their departed friend. The profuse floral offerings spoke most emphatically in silent words of the love and esteem in which the deceased was held in the community. The services at the church were conducted by Rev. AD Sheppard, pastor of the church and Rev. HD Bacon, of Portville, who was pastor of the Andover Presbyterian Church for a number of years during Mr. Eggleston's residence in this village. Mr. Bacon's remarks were in the nature of a personal tribute of a friend and brought out vividly the high character and life that had been lived in this community by the deceased.*
>
> *Rev. Vernon LeGrand Eggleston was born at Franklin, NY March 3, 1869 and died at Ontario, California August 3, 1922. As a youth the deceased was studious, and while a young man chose for his life work the preaching of the gospel. While yet as student at Colgate University, thirty years ago the 24th of last May he was ordained to the gospel ministry. After completing his studies, he held pastorates of the Baptist Churches at New Berlin, NY and Rensselaer, NY, before locating in Andover as pastor of the First Baptist Church twenty-six years ago this fall. He was also state supply pastor of the Andover Seventh-day Baptist Church for a number of years just previous to the outbreak of the World War.*
>
> *Mr. Eggleston was united in marriage on December 8, 1897 to Miss Hattie Borden, coming to Andover to reside and have always claimed Andover as their home since, tho often living temporarily in other places. Mr. Eggleston was a kind and loving husband, and their family life was most happy. During the last thirteen months thru which the deceased was a severe sufferer, the faithful wife herself an experienced nurse, has been by his side constantly ministering to him with all the devotion and care that a loving heart and skilled hands are capable.*
>
> *For several years Mr. Eggleston was a businessman in Andover, first as manager of the sanitarium and afterwards a number of years in the drug business with James D Chessman.*
>
> *When the World War broke out and the United States drawn into it, Mr. Eggleston at once began to prepare to do whatever he could do best to help his country. He enlisted with the YMCA. His ability at once was*

recognized, and he was most successful in the work. He was secretary overseas at Alsace Border, and Marseilles, France. He worked beyond his strength, while at the front, seeing much of the most intense fighting. While thus engaged carrying in the wounded, he received injuries that remained with him to his death, also contracting Vasquez Disease, with its many complication, which later resulted in his death.

After the war closed Mr. Eggleston remained in the YMCA work, acting as secretary to Hoboken, New York City; Naval Base Norfolk, Va; Cristobal, Canal Zone, Panama.

Mr. Eggleston gave his life for his country just as truly as any of the men who were at the front. He worked until he dropped in the harness, never having been able to be up and dressed in the thirteen months of his illness.

Readers of the News *have often edified and delighted in the descriptive articles Mr. Eggleston has written for them of his work in France and at other times. He was a man of broad mind, always loyal, always congenial, and always holding the love and esteem of his fellow men wherever located. He was always a Christian gentleman, wherever found.*

Funeral services for Mr. Eggleston were held at the Draper Parlors at Ontario, California, conducted by Rev. Earl Smith of the Baptist Church and Rev. Richards of the Presbyterian Church. The Masonic fraternity attending in a body. He was a prominent 32nd degree mason, holding memberships with the Panama Canal Zone Consistory, No. 1 and Andover Lodge No. 558 F&M. He was intensely interested in the fraternal work of the order. Members of the local lodge conducted a Masonic burial ceremony at the grave Sunday afternoon.

Most appropriate was the flag decoration at the church Sunday afternoon, when the Christian flag and the Stars and Stripes were draped together. He fought and died for both.

The interment of his ashes was in Hillside Cemetery, the urn being placed by Frank Longworthy, a co-worker in France, dressed in his overseas uniform.

When she returned home from California, Hattie Eggleston could not remain still for long. She went back to the work that she loved and did best. Hattie bought back the Brick and ran a birthing home until she was unable to afford the building. She later opened another birthing home on Maple Street, two houses up from Second Street. Hattie delivered over six hundred babies before she became too sick to continue her work. A party was held in her honor, celebrating her accomplishment of being in attendance at six

hundred births without losing a mother or child. The *Andover News* shared the details of the event with its readers.

> *Honors are Given to a Wonderful Woman*
> *Celebration in honor of Mrs. Hattie B Eggleston's 600 babies is held at the Baptist Church.*
>
> *The May Day party was held last Saturday evening, May 5th, at the Baptist Church* [and] *proved to be not only one of the most unique, but also one of the most thoroughly enjoyable events of the season.*
>
> *The party, as was stated in last week's news, was in celebration of the arrival of the six hundredth baby in which Mrs. Hattie B Eggleston of this village, "Mother Eggleston" as she is lovingly known in many homes in many states, had been the nurse in attendance.*
>
> *Mrs. Eggleston has welcomed babies to this old world in the states of New York, New Jersey, Pennsylvania, Colorado, California, North Dakota, Ohio and in the Panama Canal Zone, without the loss of a mother's life.*
>
> *In addition to the company of 200 guests at the May Day party, Mrs. Eggleston has received over 400 telegrams and congratulatory letters from those unable to be present.*
>
> *A company of 200 guests, the parents and grandparents of Mrs. Eggleston's babies, were in attendance.*
>
> *Dinner was served at 5:30 and 7:00; the tables were most attractive, center with garden flowers with dainty favors at each plate.*
>
> *An excellent dinner was nicely served by a staff of young ladies, most of whom were among Mrs. Eggleston's 600 babies.*
>
> *In the center of the dining room a picture of the first babe, now Mrs. Jennie McGuire Hubbard of Grand Rapids, Mich., was displayed.*
>
> *Mrs. Addie Coleman and Mrs. Orris Parker were the only great-grandmothers in attendance.*
>
> *The social hour passed rapidly in the pleasure of greeting numerous out of town guests, many of whom were former Andover residents.*

According to Hattie Gavin, a namesake of "Mother Eggleston" and one of her 614 babies, "She (Eggleston) was a very sweet woman. Everybody loved her. She did everything she could for anybody." Gavin had great memories of visiting Mother Eggleston as a young girl. At Hattie Gavin's birth, Mother Eggleston was both nurse and doctor, because the real doctor could not make it to the Gavin home in the blinding snowstorm that raged outside while Hattie was entering the world. In Hattie Eggleston's later years, she

fell and injured her shoulder so severely that her arm had to be amputated. It was then that she moved in with her niece at Cincinnatus. Nine years later, she passed away and joined her Vernon at Hillside Cemetery.

This is the obituary that appeared in the local paper.

"Mother" Eggleston Dies in Cincinnatus

Mrs. Hattie B Eggleston affectionately known in Andover as "Mother Eggleston," died early Friday morning, July 27, 1951 at Cincinnatus, N.Y., where she made her home with her niece, Mrs. Ralph Bennett since 1942. Mrs. Eggleston has been in ill health and a patient sufferer for several years.

Mrs. Eggleston was born in December 13, 1872, in Norwich, the daughter of William and Elizabeth Chapel Borden. During her childhood, she was completely paralyzed for about three years, an affliction, like many others in her life, she mastered and later graduated as a nurse from the New York City Hospital with honor of being first in her class to receive her velvet band.

December 8, 1897 she was united in marriage with Rev. Vernon L Eggleston and came to Andover to reside, where Mr. Eggleston was pastor of the Andover Baptist Church, and has since claimed Andover as her home, although her profession has taken her to many parts of the world. Rev. Eggleston died August 2, 1922 in California, the result of injuries received while moving wounded soldiers from the battlefields in World War I, in which he has enlisted in the YMCA work.

Mrs. Eggleston continued her professional work here, and about the turn of the century opened a sanitarium in what is now the Atwood Apartments on Greenwood Street (big brick house behind the bank) but was forced to give this work up because of her health. She later specialized in maternity and in her last active years operated the Eggleston Maternity Home on Maple Avenue.

Mrs. Eggleston has a remarkable record, which has been achieved by few, if any, having officiated as a nurse in charge at the births of 614 babies, and more than that, she never lost a mother and but one baby and that was the result of a prenatal condition. Her first baby was Jennie McGuire, later Mrs. Ward Hubbard of Grand Rapids, Mich., and in several instances, she officiated in second generations.

A niece, Mrs. Margery Borden Bennett of Cincinnatus, N.Y., who has cared for her the past nine years and two nephews, William and Emmett Ball of California, survives Mrs. Eggleston, the last of a family of ten children.

Services were held at Cincinnatus Saturday and at the Andover Baptist Church Sunday afternoon, the Rev. Phillip French of Vestal, NY officiated the interment in Hillside Cemetery, Andover.

When Hattie could no longer keep the Brick, she sold it to Edward Atwood, who renovated it into apartments. The building was aptly named the Atwood Apartments. There was an incident in the building that Hattie Gavin talked about in an interview as part of the documentary *Raisin the Brick*. In either 1948 or 1949, a mentally unstable woman who lived on Pixley Hill in Elm Valley walked the five miles to Andover with a malicious plan. Gladys, the woman, was jealous of her sister and her niece. She walked into the Atwood Apartments building, climbed the grand staircase and—brandishing a knife and threatening to kill them both—went out on to the roof of the front porch. An Andover police officer heard what Gladys had planned. He went to the school where the little girl was and kept her there until her aunt was taken into custody. Gladys was sent to the Willard Psychiatric Center.

The Brick changed hands several times, first becoming the Seaman Apartments and then sitting vacant from the 1980s until around 1998. The Andover Haunted House Association purchased the property with the plan to preserve its history. Through money raised as a haunted attraction during the Halloween season, repairs and restoration work have been done at the Brick. In the main hallway, near the grand staircase, are two beautiful portraits of its most loving owners, Hattie and Vernon Eggleston. The floors may be dusty and the paint peeling, but the Brick's history is still very much alive.

2

CRACKED WHEAT AND GRANULA

Dansville is nestled in a little valley flanked on the east and the west by the foothills of the Allegheny Mountains. Only twenty years before it was settled in 1795, the area was dangerous and foreboding. The colonists were in the midst of a great war, fighting for their freedom from a tyrannical England. Western New York was an unexplored wilderness at the edge of the colonial territory. Native tribes were the only inhabitants, and they were allied with the enemy. The Indians launched brutal surprise attacks, often under the cover of darkness, on anyone brave enough to attempt to settle in these remote areas. Entire families were killed and small communities wiped out. George Washington, then general over the American troops, wanted to avenge the murder of innocent citizens at the hands of the natives. He ordered Generals Sullivan and Clinton to retaliate and, most importantly, show no mercy, as none was given to the massacred settlers. What would be historically known as the Sullivan Expedition was a systematic military campaign during the American Revolution against the Loyalists and four nations of the Iroquois who had sided with the British Crown. The campaign began on June 18, 1779, from Fort Sullivan in Tioga, Pennsylvania, and cut a swath of destruction north and east as far as Leicester and Canojoharie before turning south again to join Washington's troops in Easton, New Jersey. On the way to Leicester, where the troops lay waste to Little Beard's Castle, they passed through Dansville on a trail that follows what is present-day Route 256 along the western shore of Conesus Lake. Near Maple Beach, a twenty-five-man

detachment was ambushed by an Indian war party, and fifteen of Sullivan's scouts were killed, while Lieutenant Boyd and Sergeant Parker were captured. Later, the two were brutally tortured and killed at Cuylerville or Little Beard's Castle by their captors. Many of the Native Americans who were not killed in the battles with Sullivan's and Clinton's men made their way to Canada to escape capture. As the woods were cleared of threats, people began to flood into what was then the westernmost reaches of the new nation. Fear subsided, and small communities started to pop up in remote areas, often a day or two's ride from the nearest city. This was the case with Dansville.

Dansville was once home to a unique and interesting institution. Most people do not know that Dansville's Castle on the Hill even exists. During the spring and summer, the dense foliage conceals its secret. In autumn, as the leaves turn vibrant reds and oranges and begin to fall, glimpses of the massive structure may be caught by motorists who know when and where to look on the interstate. It is then that the beauty of the castle is fully captured. The foothills of the Allegheny Mountains protect it well.

The original Castle on the Hill was conceived as a business venture meant to capitalize on the fashionable trend of the day, the water cure. In 1796, Dansville was a small village of settlers who came north from Pennsylvania under the leadership of Daniel Faulkner. They had strict values, feared God, believed in superstitions and had strong work ethics. Every day was like the day before and the day before that. So, you can imagine the commotion that ensued when the ground began to shake beneath their feet. They ran up East Hill, which rises about Route 256. The people in the village found that a gushing spring had broken through the solid stone on the hill. In eighteenth-century America, much of the mechanics of science were only understood by the scholars at prestigious colleges. At the time, the concept of earthquakes was foreign in small farming communities. In a town where religion was the backbone, the villagers thought that God had brought forth the spring and it had the power to cure the sick. As a result of this line of thought, the well was called the "All Healing Spring." News of the spring was kept within the town, not because the people wanted to keep it to themselves, but for the simple reason that Dansville was so far from the nearest city.

Fifty years after the spring started flowing, a businessman from Rochester heard about the pure water and made the trek south to see it for himself. He was more than impressed by what he saw. Nathaniel Bingham, along with a team of investors, believed that the mineral-rich East Hill spring would be an ideal location for a water cure.

Europeans flocked to water cure spas, and they began popping up in the United States. In the mid-1800s, people had a growing interest in alternative medicines, even though the fascination with water as a cure-all has been timeless. Water cures were built on the theories surrounding the health benefits of water, beyond just drinking eight glasses of it a day. The earliest indication that people harnessed the therapeutic powers of water were discovered in ancient Greek texts from around 2000 BC. In fact, Hippocrates prescribed spring-water baths for the treatment of various illnesses. The Bible also referenced it in Ezekiel 36:25: "I will sprinkle clean water on you, and you will be clean; I will cleanse you from all your impurities and from all your idols." Sanitation became a problem in medieval Europe, and pure, clean water was difficult for the common man to find. As a result, the practice of hydropathy was only available to the nobility. In the eighteenth century, doctors began researching in depth the medicinal qualities of water.

By 1850, there were almost two hundred water cures across the country. Even nearby Avon, twenty-eight miles from Dansville, had one. That did not deter Bingham from opening the Dansville Water Cure. The curative and restorative powers of spring water were hyped up by the owners, some of whom were doctors. Brochures laid it on thick that the spring's water could cure a long list of illnesses ranging from "hiccups to cancer," of which no one had any scientific proof. I am sure that one water cure spa probably advertised that it could even cure hydrophobia. Advances in pharmaceuticals and medicine diminished the power of water. Water cure spas were downgraded to vacation resorts meant to rejuvenate their guests. Claims to cure actual illnesses were no longer made. All this change came about at the turn of the twentieth century. However, when water cures first came to America, the majority of them were run by doctors with the intent to treat and cure.

Nathaniel Bingham was not a doctor but a piano and cabinet maker. He was a simple businessman from the city looking to make a fast buck. The Dansville Water Cure opened its doors in 1854 under the ownership of Bingham and his partner Lyman Granger. Unfortunately, Bingham became ill shortly after the grand opening, and he was forced to sell his share of the business. It changed hands several times over the next four years; no one was ever able to make the water cure a success. That was because none of them had the passion for hydropathy, or hydrotherapy, but Dr. James Caleb Jackson did when he took it over on October 1, 1858.

James Caleb Jackson was a sickly child, and as he grew older, his health only declined further. Working was difficult, and at times, performing normal

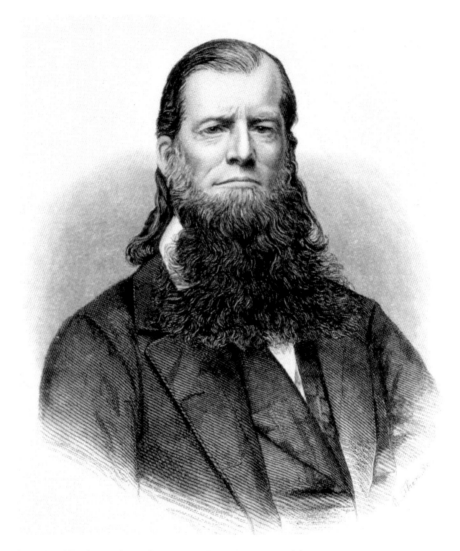

Portrait of Dr. James Caleb Jackson. *National Library of Medicine.*

daily tasks proved to be impossible. It was only after visiting a water cure that Jackson received relief from his health problems; in fact, he claimed that after the visit, his many ailments were miraculously cured. Jackson was a walking testimonial to the health benefits of water. He became one of water cure and alternative medicine's biggest and most vocal advocates at the time. Jackson attended medical school in Syracuse and opened Glen Haven, his own water cure, on the shore of Skaneateles Lake. Unfortunately,

it was destroyed by fire, and his insurance was not enough to cover the cost to rebuild. However, Jackson did not give up on his dream, and when he heard that the Dansville Water Cure was up for sale, he did not hesitate to purchase it. The first thing that Jackson did once he acquired the venue was change the name to Our Home on the Hillside.

Dr. Jackson not only promoted good health through the use of hydrotherapy, he pushed good eating habits as well. In essence, Our Home on the Hillside was a naturopathic hospital, which is defined by Merriam Webster as "a system of treatment of disease that avoids drugs and surgery and emphasizes the use of natural agents and physical means." His health resort in the tranquil hills of the Finger Lakes became a mecca for the rich and famous—even a few controversial characters as well—such as Frederick Douglass, Susan B. Anthony and Horace Greeley. Jackson published several books over the course of his career on subjects that affected the health of the nation, focusing on diet, disease and sexual issues.

As a nineteenth-century nutritionist, Dr. Jackson was one of the most influential figures in the history of alternative medicine and a champion of "clean eating." There were six things that were strictly prohibited from Our Home on the Hillside: red meat, sugar, coffee, tea, alcohol and tobacco. Fresh fruits and vegetables and whole grains were served instead. Jackson was aware that the average person's diet was heavy in fats and proteins, which he believed were the cause of the majority of the health problems that people faced at the time. The traditional breakfast consisted of bacon or ham, which is full of fats and salt, and eggs. To start cleaning up America's diet, he decided to change the face of breakfast, often referred to as the most important meal of the day. People needed a solid, healthy meal to begin their day. Jackson invented the first "ready to eat" cold breakfast cereal. Taking advantage of the abundance of locally grown grains, he baked the bran from the grain with graham flour and water to make what he called Granula. Granula was then broken into nuggets and soaked overnight in milk before eating.

Most people are familiar with a similar product called granola, marketed by the Kellogg's company. The first granola was made from ground oats, wheat and corn. Dr. John Harvey Kellogg stole the idea for his cereal from Dr. Jackson. But how? They were thousands of miles apart. Kellogg had heard about Jackson's spa, Our Home on the Hillside, from a member of a church in Michigan who had been treated by Dr. Jackson. John Kellogg paid Jackson a visit in 1878 on what could be called a reconnaissance mission to learn Jackson's methods. Jackson was more than happy to share

his theories and findings with a fellow physician. This would prove to be a major mistake. Two or three years later, Kellogg began marketing his own cereal, which he also dubbed Granula. It did not take long before Jackson heard about what Kellogg was up to, and he filed an infringement lawsuit. Of course, Jackson won his case, and Kellogg was forced to change the name of his cereal to Granola. In 1897, C.W. Post introduced his own version, Grape-Nuts, which is still popular today.

Soon after the lawsuit was settled, James Caleb Jackson retired and turned the business of the water cure spa over to his children. Although he was no longer involved in the day-to-day operations of Our Home on the Hillside, Jackson still remained close to the action. The family owned a house, nicknamed Brightside, across the street from the spa's property. That is where he spent the rest of his days until his passing on July 11, 1895.

After Jackson's children took over their father's life work, tragedy struck. There was no electricity at Our Home on the Hillside; lanterns and candles were used throughout the buildings for lighting. During the night of June 26, 1882, a lantern overturned in a patient's room. The kerosene spilled out and ran along the floorboards, making it impossible to stop the flames from spreading. By the time the fire crews arrived on the scene, there was no chance of saving the building. Firemen concentrated their efforts on keeping the fire from spreading to other buildings. By dawn, the wooden structure had been reduced to a pile of ashes and charred beams. Fortunately, no one was killed in the fire, and there was no mention of injuries. The June 27, 1882 issue of the *Daily News* out of Batavia reported on the fire:

Dansville's Water Cure Burned

The explosion of a kerosene lamp in the room of a patient at "Our Home on the Hillside" at Dansville set the building on fire last night and it was burned to the ground in an incredibly short space of time. The inmates were all removed safely and were cared for in the surrounding cottages, the seminary and the village hotels. The loss on building and contents is estimated at $50,000, and a large numbers of persons are thrown out of employment. It will probably be rebuilt.

The coverage of the fire was seen in papers as far away as Buffalo. On June 27, 1882, the *Buffalo Morning Express* had this blurb for its readers:

Fire in Dansville

June 26—At 10:30 this evening fire was discovered in the west end of the main building of our home hygienic institute, Austin Jackson & Co., proprietors. The building was totally destroyed. The 300 occupants escaped with most of their goods. The firemen saved Liberty Hall, which was joined by a corridor; also the adjoining cottages. Valuation $50,000; insurance on building and contents $35,000.

When the smoke cleared, the main objective was to rebuild and do it quickly. One year later, a five-story brick building stood in its place. A grand opening was held on October 1, 1883, twenty-five years to the day that James Caleb Jackson opened Our Home on the Hillside. With the rebirth of the building came a new name, the Jackson Sanitarium.

The Jackson Sanitarium expanded its services, including the Jackson Sanitarium Training School for Nurses, which graduated its first class in 1904. All of the additions and changes only delayed the inevitable. Advances in medicine and pharmacology offered new ideas that put the

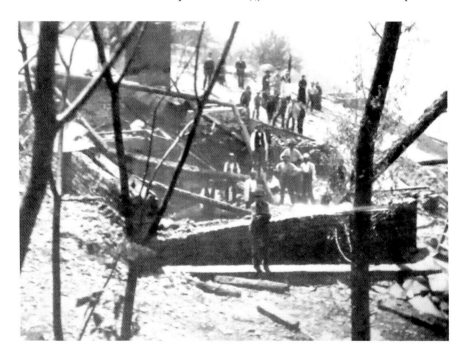

Our Home on the Hillside in ruins the morning after the fire on June 26, 1882. *Dansville Area Historical Society.*

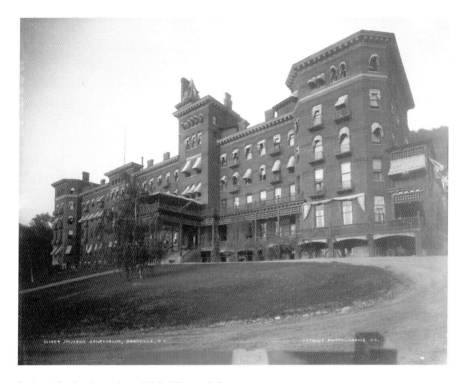

Jackson Sanitarium, circa 1890. *Library of Congress.*

faith of the general public back in traditional medicine, and attention turned away from popular alternatives. The Jackson Sanitarium closed its doors in 1914. Two years later, ownership was transferred to William Leffingham.

Leffingham was a shrewd businessman. With the United States' involvement in World War I came the need to have hospitals stateside to treat the returning servicemen. Leffingham wanted to see that the government's need was filled. The U.S. Army signed a contract to use the property as a hospital, known as General Hospital No. 13. With its opening in November 1918 came 100 to 200 soldiers with psychoneurosis, or PTSD. An audit at military headquarters in Washington, D.C., found that many services were being duplicated at some of the contracted facilities, and there was not a need for as many hospitals as had been leased. That was bad news for Leffingham and the Town of Dansville. Within four months and 368 patients later, the army closed the hospital on March 19, 1919.

The future of the old Jackson Sanitarium seemed bleak, and for a long decade, the massive building stood empty. But in the spring of 1929, Bernarr MacFadden breathed new life in to it. Bernarr was born a sickly child. By the time he was eleven, both of his parents had passed away, and he became an orphan. The state placed MacFadden on a farm, where he quickly discovered that the physical labor and wholesome food made him healthier and stronger. This was the beginning of the road to sharing with the world his fitness beliefs and becoming one of America's top experts in regards to healthy living. His emphasis on a healthy diet was similar to that of the former Our Home on the Hillside owner Dr. Jackson. Although Bernarr MacFadden had many business successes and failures in his lifetime—really, too many to go through—for the purpose of this book, I am going to discuss only his time in Dansville.

MacFadden was a health fanatic, former professional wrestler and body builder and the publisher of the magazine *Physical Culture*, after which he named his latest acquisition. The hotel offered an array of exercise and wellness opportunities for his guests, including tennis, swimming, hiking and golf. Guests could also take advantage of the therapeutic treatments that were available. Bernarr was a wealthy and popular man—the list of his friends reflected that. Many of those friends and acquaintances visited his resort in western New York. It was common to see senators and political powerhouses, Hollywood actors and socialites strolling through downtown Dansville. It again became a popular getaway for the rich and famous, even during the Great Depression. Old-timers in town still remember attending dances on the hotel roof.

It is interesting that a twentieth-century health guru purchased the property of a nineteenth-century alternative medicine advocate. Like the regimen offered at Our Home on the Hillside, Bernarr ate a raw food diet and instructed his guests to eat enzyme-rich foods in order to maintain vitality and ideal health.

Shortly after the opening of the Physical Culture Hotel, MacFadden and a crowd of his followers embarked on two-week-long marches to promote his regimen of diet and exercise. The marches departed from New York City, Philadelphia and Cleveland, arriving hundreds of miles later at the hotel in Dansville. They were called "Cracked Wheat Derbies" by the media because the only food hikers consumed was cracked wheat with grapefruit, raisins, honey and brown sugar. Each march ended with a parade, complete with all the pomp and circumstance fit for royalty, followed by a huge meal and celebration. A newspaper article in the

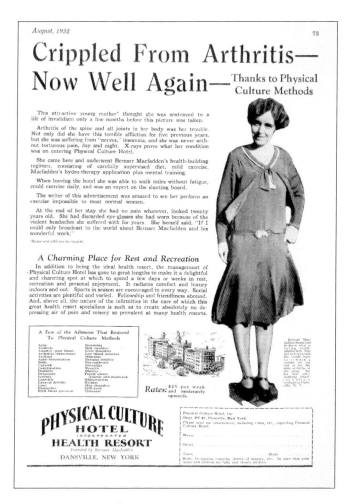

A 1932 advertisement for Bernarr MacFadden's hotel in Dansville. Ads like this appeared in magazines all over the country. *Dansville Area Historical Society.*

Wayne County Times on June 24, 1937, reported on the arrival of a group lead by MacFadden in Dansville:

> Score another triumph for Bernarr MacFadden and his 48 men and women guests who leisurely strolled the highway 325 miles from Broadway to Dansville, arriving at Physical Culture Hotel on the hillside overlooking Dansville Friday, June 4, where a distinguished reception committee welcomed them into the Genesee Country.
>
> Virtually all the hikers had discarded one pair of shoes. Shoe tops had been cut away to create a sandal-effect and ease foot sores. Blisters, with few exceptions, however, had become calloused after the first few days.

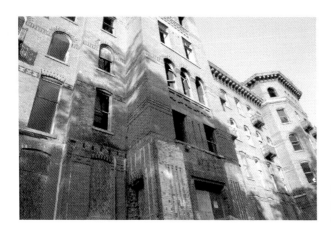

Castle on the Hill in near ruins, around 2012. *Author photo.*

Upon arriving from a Crack Wheat Derby that started in Cleveland, Bernarr MacFadden quipped:

They've found the fountain of youth. It flows in our feet. I wish every man and woman could learn that. Nobody needs any gland transplantation, any operation, to become young again. He needs only walk. These people are proof of that statement. Talk to some of them and you'll be convinced.

MacFadden died in 1955 at the age of eighty-seven. After his death, William Fromcheck, a New York City hotelier, bought the hotel and continued to operate it as a health spa. It was called Bernarr MacFadden's Castle on the Hill. The fad of the health resort began losing ground, just like the water cure had. In 1971, the Castle on the Hill closed for good at the end of its summer season.

Five and a half decades of harsh winters have taken its toll, it remains empty and in a state of indescribable disrepair and despair. Many of the buildings have fallen victim to arson and vandals with no respect for its wonderful history. In April 2011, the outer wall of the south end of the castle collapsed into a pile of rubble. What human hands have not destroyed, Mother Nature is slowly reclaiming as her own.

3
DAREDEVILS

There has never been a time that Americans were not obsessed with daredevils, sideshow freaks and circuses. Today, we push the envelope pretty far in order to get a thrill; it was much the same in the nineteenth century. These historical figures pushed their envelopes farther than they had ever done before. And as long as someone was willing to perform, the crowds were guaranteed to come.

The first American daredevil was the "Yankee Leaper," otherwise known as Sam Patch. Patch was born in 1799 in Pawtucket, Rhode Island, which was where he performed his first jump. He worked at Slater Mill as a mule spinner when he was a young boy—a time when child labor laws had not even been given a thought. Patch and his friends swam in the water of the millrace, and he often jumped from the milldam. Then, his friends jumped off a bridge into the Blackstone River. Each tried to outdo and impress the others. Patch looked for higher perches to dive from, and few boys were brave enough to leap from the heights that he did. What started out as boyhood antics soon began drawing crowds of people. He continued his daring jumps from heights that grew higher and higher. Patch moved to Paterson, New Jersey, and found work at a local mill. He was then around twenty-seven years old, but the young man had not outgrown his penchant for leaping from high places into turbulent waters below. He set his sights on a new and his highest platform to date. When it was announced that a bridge was being built across the Passaic River, Patch vowed to make it his next feat. People in Paterson and the surrounding areas enjoyed watching the construction

of the bridge, and Patch used that to his advantage. Wearing his underwear and a shirt, he walked out onto a perch, then jumped. The spectators were shocked, and entertained, by what they had just seen. The eighty-foot leap earned Sam the nickname "Patch the New Jersey Jumper."

He set his sight on bigger targets, and two years later, Patch found himself standing above the churning currents of Niagara Falls. On October 7, 1829, he stood on a platform built on Goat Island. The *Colonial Advocate* reported on his jump: "He walked out clad in white, and with great deliberation put his hands close to his side and jumped from the platform into the midst of that vast gulf of foaming waters from which none of human kind had ever emerged in life."

Emerge he did, surviving a jump that no one had lived through before. The *Buffalo Republican* shared with its subscribers—the few who had not witnessed it for themselves—that "[t]he jump of Patch is the greatest feat of the kind ever effected by man. He may now challenge the universe for a competitor."

No one dared to match Patch's jump. Ten days later, he jumped again, from a platform set even higher above the falls, a dizzying 125 feet. The crowd was not disappointed.

Never satisfied and always looking for the next thrill, Patch and his new pet black bear headed east to Rochester. Advertisements in the Rochester papers set the date and time for his jump, November 6, 1829, at 2:00 p.m. The ad stated that his bear would be jumping with Patch too. Before a crowd of eight thousand spectators, on a platform ninety-seven feet above the Genesee River at High Falls, Patch pushed his bear off and then followed him into the water—another successful performance. Even though the crowd was huge, the payout was not. For the sole reason of not making enough money, he decided to repeat the jump a week later.

Posters and advertisements for his second jump on November 13 were displayed all over the city. They promised that Patch would perform an even more daring feat, "Sam's Last Jump!," certainly meaning at press time that it was his last jump of the season. The platform was raised to 125 feet. Before Patch made his jump, he gave a speech to the crowd. His last words were, "Napoleon was a great man and a great general. He conquered nations, but he couldn't jump the Genesee Falls."

And with that, he jumped from the platform. What happened next was unclear; some say that something went wrong with the jump, while others say that Sam Patch was drunk when he left the platform. Did he hit the rocks that jutted out from the gorge wall on the way down, or did he just

Sam Patch jumped from high above Niagara Falls in October 1829. The death-defying leap made him famous, and Patch became a household name. This is the cover art for the 2003 book by Paul E. Johnson, *Sam Patch, the Famous Jumper*. *Slide Share*.

> **SHOCKING EVENT!——SAM'S LAST JUMP!**
>
> Thousands collected yesterday to witness Sam Patch's "*last Jump*," as the bills expressed it—and an awful leap it was! He never rose with life!
>
> A stage, 20 feet high, had been erected on the edge of the falls, which made a descent of about 120 feet to the surface of the water in the chasm below. Sam apparently lost his balance—struck the water in a sideling manner—and disappeared to rise no more! Such a shocking result had a strong effect on the immense crowd. After waiting in breathless anxiety for some time, the multitude dispersed with feelings which can be better imagined than described. The corpse is not yet found.

This is an excerpt from an article that appeared in the *Rochester Daily Advertiser* after Sam Patch's final jump. *Rochester Daily Advertiser*.

hit the water too hard? What everyone can agree on is that Sam Patch did indeed leave the platform and plummet the 125 feet to the river below. The crowd held its collective breath for what seemed like an eternity, but Patch never resurfaced. His advertisement proved to be prophetic. On a side note, November 13, 1829, was a Friday. Perhaps his luck had simply run out. On November 14, 1829, New York's *Saturday Evening Post* gave Sam Patch a glowing review:

> *The now distinguished name of Sam Patch, which erst had never been pronounced out of the little town of Paterson, is rapidly running the honorable circle of newspaper eulogy, from Maine to Georgia. Wherever Sam goes, he meets with welcome! The good people of every town anticipates his arrival, and not a man, woman, or child, are content, till they hear from his lips that there is no mistake.*

At the time the paper hit the streets on the morning of the fourteenth, Sam Patch was dead. Neither the article's author nor the newspaper had any idea of the fate of Sam Patch at press time.

A few months later, his body was found frozen in the ice downstream at Charlotte, near the shore of Lake Ontario. He was buried in Charlotte Cemetery on River Street without the pomp and circumstance befitting a famous entertainer. A wooden marker over his grave read, "Sam Patch—Such is Fame." After 187 years, the wooden marker is gone, as is the exact location of this

exciting man's final resting place. According to an April 1925 obituary, Mary Ann Davis passed away at ninety-five years old, and she was the last living person who knew where Patch rests. With that, his grave was lost to history.

When Sam Patch died during his last jump, local clergy and a select few others blamed the spectators for his death. The *Anti-Masonic Enquirer* said it was "[a] daring and useless exposure of human life [that left the crowd] abashed and rebuked [after seeing] frail mortal, standing, as it proved, on the brink of eternity."

It would be decades before a new daredevil captured the region's attention the way that Patch had. A gentleman by the name of Jean François Gravelet Blondin was responsible for reigniting the fire. And all he did was stretch a rope high above Niagara Falls and walk it. After that, a new breed of daredevil was born to entertain the masses.

Falls Field, on the eastern side of the Genesee River gorge near Platt Street, was the site of Patch's daring and final jump. It also played host to another daredevil to visit Rochester. N.P. Demarest, the owner of Falls Field, was looking for a way to bring more business to his saloon and beer garden. Demarest brought in French tightrope walker Anloise De Lave to boost revenue. De Lave laid his rope across the gorge, 110 feet about the river, and walked. His first walk on August 16, 1859, drew a crowd of eighteen to twenty thousand spectators—filling all the hotel rooms in the city and giving the local taverns a windfall. For two weeks, he wowed thousands of people. Each walk was a two-for-one, a bargain for twenty-five cents; De Lave crossed the gorge and then turned around and crossed it again. During the August 16 walk, he stopped halfway over the gorge, lay down and then got up to stand on one leg. Each trip across the rope featured different stunts so that no two days were the same. People saw as many performances as their wallets and change purses would allow.

While De Lave's performances were entertaining, they drew much criticism. Young boys and men tried to imitate his dangerous stunts and injured themselves, sometimes seriously. The show, however, went on. The last of his walks was the most daring of them all. Robert Smith, a local Rochester man, volunteered to be carried by De Lave—high above the falls—from one side of the gorge to the other. Part of the way across, De Lave slipped, both men fell and the crowd gasped. Fortunately, they both had the presence of mind to grab hold of the rope and made their way, hand over hand, to land. Neither man died that day; however, a spectator fell over the edge into the gorge and was instantly killed.

At the same time that De Lave was walking the rope in Rochester, two young men thrilled the masses in Brockport. For the Cornes and Parker rope walking exhibition, they crossed over the Erie Canal between the Holmes House and the American Hotel. Before a crowd of hundreds of people, Cornes and Parker started walking from opposite sides. When they met in the middle, Cornes lay down on the rope as Parker stepped over him. Their stunts went off without a hitch. The next one was not so uneventful.

Three months after Blondin crossed Niagara Falls, the entire population still had a severe case of "tightrope fever." At the time, the Orleans County Fair was held in Albion, instead of Knowlesville, as it is today. On September 28, 1859, during the fair, a daredevil from Brockport strung his rope from the second floor of the Mansion House across the canal to the second floor of Pierpont Dryer's building. Hundreds of people lined the canal bank and streets. About 250 more people and a few horses packed on to the three-arched iron drawbridge on Main Street to get a better view. As the rope walker started out the window of the Mansion House, the bridge began to moan, and then it collapsed under the tremendous weight of the crowd. The canal was instantly filled with bodies. Those who could swim made it to shore, while onlookers pulled those they could reach from the water. People were trapped in the debris from the bridge and under the bodies of those who had landed on top of them. Witnesses said that the horses that were on the bridge thrashed in the waster after the bridge collapsed, contributing to the injury and death count. At the end of the day, at least fifteen people were dead, mostly children, and scores were injured. Nearly a century and a half later, in 2002, a marker was erected by the Orleans County Historical Society as a solemn reminder of that tragic day.

When there were no daredevils in town, the circus thrilled the crowds. At the turn of the twenty-fist century, the only show under the classic big top was the Barnum and Bailey Circus, but in the 1800s, dozens of circus troupes crisscrossed the country. Late at night, circus wagons pulled into the city of Rochester and began setting up in Falls Field. Even though they arrived under the cover of darkness while the city slept, word traveled fast, and by mid-morning, Rochestarians were waiting for the parade to begin. The parade was almost as exciting as the big show itself. It gave people who could not afford the price of admission a chance to enjoy a small part of it all. The *Rochester Republican* wrote this about Spaulding's Monster Circus:

> [T]*he unparalleled celebrity of the company and the magnificent spectacle presented by their triumphal procession in the morning drew together a*

crowd…never before witnessed at one time under one pavilion…not less than four thousand persons, many of them consisting of groups of ladies and gentlemen who for the first time now attended a circus.

In the mid-nineteenth century, circuses usually just had plays, equestrians and acrobats. It was P.T. Barnum who introduced elaborate animal exhibitions and sideshow acts, becoming synonymous with the circus. In the late 1860s, Barnum returned to Rochester as Barnum's Greatest Show on Earth. Trumpeting elephants and a lively steam calliope—which could reportedly be heard twelve miles away—announced their arrival. An 1868 *Union and Advertiser* article described "the colossal leonine car, bearing beautiful women, in the center of which a large living lion, uncaged and unchained reposed in all his majesty near his keeper."

People began to crave more thrills, becoming "circus-mad." They flocked to freak shows and sideshows, shelling out their hard-earned money for a chance to peek into a tent and catch a glimpse of the Wild Boy of India, who was raised by wolves; the Fiji Mermaid; and other exotic and bizarre spectacles. Curiosity emporiums, museums of the odd and macabre, began to spring up across the country in general stores and tavern back rooms everywhere, ready to feed the fascination one nickel at a time. One man came to Rochester to set up a show and became a local icon.

Rattlesnake Pete, born Peter Gruber in 1858 in Oil City, Pennsylvania, was the son of an oil refiner. He had always had an obsession with snakes and reptiles. At a young age, Peter learned from the local Seneca Indians how to catch rattlesnakes, copperheads and other adders. From their medicine woman, he learned how to use the serpents to make medicines and antidotes, as well as clothing from the skins. Keeping with native traditions, no part of the animal was wasted.

When Pete's father left the oil business, he and Peter opened a restaurant/saloon with a museum on the side. In 1892, Oil City, ninety miles north of Pittsburgh, fell to disaster in the form of floods followed by massive explosions and fire that destroyed the already-crippled city. Nearly everything lay in ruin, including the Grubers' saloon. With nothing left at home, Peter moved north and settled in Rochester.

Once in Rochester, he opened a saloon and curiosity emporium at 8–10 Mill Street, behind Reynolds Arcade. In his emporium, he had not only snakes and reptiles but also a vast collection of strange items bordering on the macabre. Rattlesnake Pete's collection included the corpse of a petrified woman, the battle flag from Custer's last stand and what he claimed to be

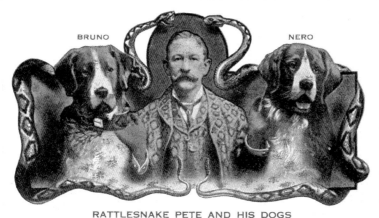

Calling card of Peter Gruber, a.k.a. Rattlesnake Pete, featuring Pete and his two dogs Bruno and Nero. *Rochester Public Library.*

one of the very first electric chairs. Pete also had personal belongings of John Wilkes Booth and James brothers, as well as the very weapon used by a wife-killing axe murderer.

He sold venom and oils from the snakes he captured, as well as things he made from them. True to his nickname, Rattlesnake Pete not only kept the slithering creatures, he also dressed from head to toe in their skins. According to stories passed down throughout the years, he once saved a circus clown who had been bitten by a rattlesnake. Pete also treated hundreds of people with goiters by wrapping his snakes around their necks; the gentle, massaging movements of the snake's muscles relieved their discomfort. In Arch Merrill's *Rochester Scrapbook*, the author further relayed Rattlesnake Pete's place in the community: "Whenever any strange animals showed up in Rochester, Pete was sent for…to pick up sinister lizards from banana shipments in the railroad yards, to capture monkeys escaped from a carnival, to kill snakes, invariably harmless ones, that householders found in their cellars."

Pete was a Victorian version of Billy the Exterminator. He was quite the character and definitely marched to the beat of his own drum. Peter Gruber died on October 11, 1932. His collection was auctioned off, never to be displayed again. With that, he slipped into history as someone people called larger than life. He is buried in Holy Sepulcher Cemetery.

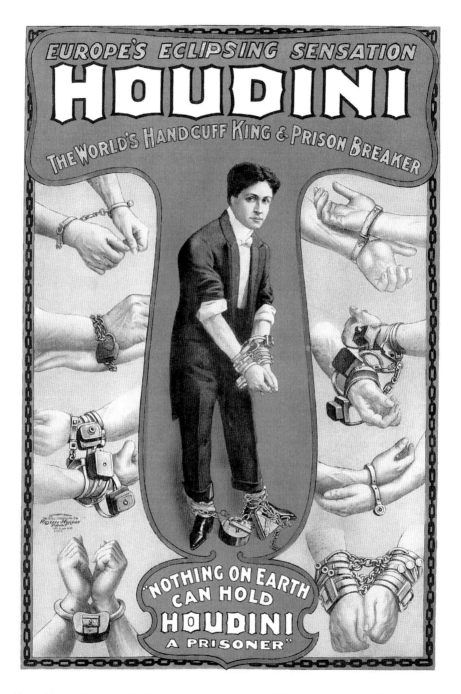

Harry Houdini came to Rochester and performed one of his greatest escapes, jumping into the Erie Canal wearing double handcuffs. This is a 1920s poster depicting many of the stunts he performed while having his wrists shackled. *Library of Congress.*

Finally, one of the greatest and most famous daredevils and escape artists of all time made an appearance in Rochester. In May 1907, Harry Houdini, accompanied by his wife and mother, came to the Flower City to perform one of his greatest and most popular stunts. Houdini climbed atop the Weighlock Bridge near Court Street, from which he jumped in to the Erie Canal wearing not one, but two pairs of handcuffs. The entire stunt, for the first time ever, was being filmed. The film used in the camera was none other than Rochester's famous Kodak film. The *Union and Advertiser* chronicled the event:

> *Mounting to the top of the bridge truss Houdini waved his manacled wrists to the crowd, shouted "good bye" and leaped. As he entered the water he burst* [a] *pair of cuff*[s] *asunder. Fifteen seconds later he reappeared with the other pair of cuffs dangling from one wrist and then sinking again he came to the surface again with the cuffs completely unfastened, waved them above his head and swam to the towpath.*

For over two hundred years, the Finger Lakes have had a love affair with thrills and drama. To quote Molly Kirker, "[T]he American dream [is] a belief that human ingenuity can generate endless, perhaps even extravagant possibilities."

4
DEVIL'S NOSE

Lake Ontario and the topography of its shoreline were carved out by receding glacial ice over eleven thousand years ago. What was revealed from under the ice were deep lakes, high bluffs and sandy beaches that have further been sculpted and softened by thousands of years of gentle waves and the fury of powerful storms. Devil's Nose is one of those glacially formed bluffs. It is on the western edge of Hamlin Beach State Park, about twenty miles west of the Port of Rochester at Charlotte. The steep sand bluff is about forty feet high. It used to be higher, one of the highest points on the southern shore of the lake, but rising lake levels and erosion by the wind over time have slowly shrunk it. Although the bluff is unstable because of the shifting sands, the real danger of Devil's Nose is in what lies beneath the surface of the lake. A rocky clay shoal nearly a mile long, waiting to trap unsuspecting ships, stretched out from the shore. From oceantreasures.org, "The *Coast Pilot*, which was once the Bible of navigators, warned sailors to keep a half mile off shore for good water as there was a 'dirty spur' almost a mile east of Devil's Nose with only a foot of draft on it, roughly three-eights of a mile out."

In the early days of Great Lakes shipping routes, from the mid-eighteenth to early twentieth centuries, ship sailed within a mile or two of the shoreline during rough and stormy weather. In most cases, sailing half a mile to a mile was a safe practice, especially in blinding snowstorms, so that the ship could keep track of land and not get disoriented. But that train of thought would not always prove to be safe. The shore near Devil's Nose was unassuming,

its danger hidden from view except during inclement weather. When the lake waters grew angry, the truth showed itself, as the churning waters broke against the rocks jutting out from the shoal. Devil's Nose became known as a graveyard of many ships.

Shortly after the British settled the first colonies in North America, the first ship set sail to explore the Great Lakes. *Le Griffon* was launched on the Niagara River near Buffalo in 1679. Thus began the rich tradition of shipping and sailing on the lakes. With lake travel came shipwrecks. The first documented shipwreck was in 1679 on Lake Michigan; the record of its identity has been lost long ago. For every shipwreck that is listed in the logs, journals and databases, there is one that has slipped under the surface unrecorded.

As western migration opened up new territories, Lake Ontario became a busy shipping route for both cargo and passengers. The first ship to be claimed by Devil's Nose wrecked over two hundred years ago. The *Duchess of York* was manned by British soldiers carrying passengers and a variety of cargo. The ship was caught in a furious November storm on its way up the lake in 1799. It inadvertently passed over the shoal and became hopelessly stuck on the rocks. As the storm raged on, the passengers and crew boarded a deck boat and proceeded to sail on to Kingston, Ontario, Canada. The *Duchess of York* was doomed to break up on the rocks, as the powerful waves crashed against the hull and its cargo was lost. In fact, there were many newspaper accounts from passing ships that the *Duchess of York* was stuck fast and starting to founder. The *Niagara Constellation*, a newspaper out of Niagara-on-the-Lake, published this on December 7, 1799: "On Thursday last, November 29th, a boat arrived here from Schenectady. She passed the *York*, sticking on a rock off the Devil's Nose. No prospect of getting her off."

According to the *Upper Canada Gazette* on December 21, 1799, "[W]e hear from a very good authority that the schooner *York*, Captain Murray, has floundered and is cast upon the American shore about 50 miles from Niagara, where the captain and his men are encamped. Mr. Joseph Forsyth, one of the passengers hired a boat to carry them to Kingston."

The luck of the *Duchess of York*'s refugees was nothing but bad; when their boat was about twelve miles from Oswego, it sprung a leak and sank to the bottom as soon as the last passenger was rescued by a passing ship. One could say that they had very good luck, for they managed to survive two sinking ships within a matter of days. The fate of every ship caught up at Devil's Nose would not be as fair.

In November 1862, the schooner *C Reeve* left Chicago for Oswego with 13,500 bushels of corn. The *Exchange* left Oswego with 2,000 barrels of Onondaga salt destined for cities on Lake Erie. The fate of these two ships would meet on November 22 at Devil's Nose. Late in the afternoon, a strong wind from the north heralded a blinding snowstorm with zero visibility. Shortly after the storm began, as neither ship saw the other, the *Exchange* rammed the starboard side of the *C Reeve*, leaving a gaping hole in its hull. Water poured in, and within a matter of minutes, *C Reeve* sank. The *Exchange* also was badly damaged, but the crew managed to get everyone off the *C Reeve* on board before turning around and limping back to the Port of Rochester. The *Rochester Union and Advertiser* reported that the *Exchange* "bears the marks of a collision and reminds one of a bully with his nose badly broken."

Another ship that met its demise on the rocks of Devil's Nose was the *Undine*, on November 1, 1890. The two-masted schooner had a hull full of coal headed for Sodus, New York, when it was caught in a gale and hit the shoal. The rocks ripped a hole in the *Undine*'s bottom on impact, allowing water to rush into the hull so fast that the pumps could not keep up, and it sank. The crew was able to board a yawl as the ship started to go under and sailed the twenty miles to Charlotte.

The *Undine* was not the last ship taken by Devil's Nose, but there were few after it. After 1903, Devil's Nose would claim no more—the *Reuben Doud* being the last—but the icy depths of the Great Lakes continued to swallow prey.

5
DEWITT CLINTON GUY

In Fairfield Cemetery, a small burial ground in the Erie Canal village of Spencerport, is the grave of a soldier who fought for "the cause" and had his heart divided between the North and the South. According to the book *The Confederate Soldiers of Rockbridge County, Virginia: A Roster*, by Robert J. Driver Jr., DeWitt Clinton Guy was born in Lockport, New York, where his father was working on the Erie Canal. His father was from New York State but found construction work on the James River and Kanawha Canal, which brought him to Lynchburg, Virginia, where he met his wife. When the enlargement of the Erie Canal began in 1840, the Guy family left Lynchburg and traveled north to Lockport. It was there that DeWitt Clinton was born. He was named after a former governor of New York and the man responsible for the building of the great Erie Canal. Construction work on the canal was dangerous. It claimed the lives of nearly one thousand men between 1817 and 1825, with hundreds more during the expansion. The Guy family patriarch was one of those casualties. He was killed in a cave-in while working on a lock. After the death of her husband, Mrs. Guy packed up her children and moved back to her hometown of Lynchburg.

At the age of nineteen, DeWitt Clinton Guy answered the call that thousands of young men throughout the South heard. He enlisted in the Eleventh Virginia Infantry, Company G, on April 23, 1861. His brother John enlisted a year later. DeWitt carried a family Bible with him when he went off to war. In the Bible, he kept a journal. The first entry that he wrote was on the first day he saw fighting on the battlefield. According to the

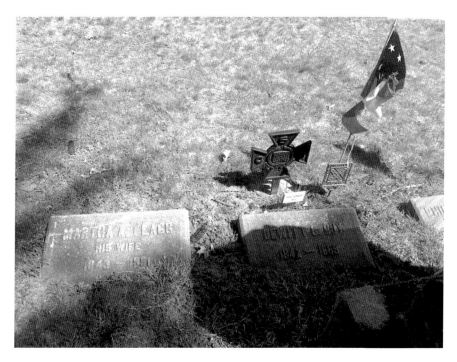

These are the graves of Dewitt and his wife, Martha, at the Fairfield Cemetery in Spencerport, New York. DeWitt Clinton Guy carried a family Bible into battle when he left his Lynchburg, Virginia home. More than a century after his death, Guy's family in New York donated his Bible to the Lynchburg Museum. His name is inscribed on the title page. *Lynchburg Museum. Author photo.*

entries, he was wounded in the Battles of Seven Pines in Virginia; Drewry's Bluff in Chesterfield County, Virginia; and Gettysburg, as part of Pickett's Charge. As often as he could, he wrote in that sacred journal. He marched thousands of miles through the mountains of Virginia, Pennsylvania and Maryland. The final entry was made when he was held as a prisoner of war at the Union-run Camp Hoffman at Point Lookout, Maryland. The Civil War ended when Confederate general Robert E. Lee surrendered to the Union's Ulysses S. Grant on April 9, 1865, at Appomattox Court House. Camp Hoffman closed in June of that year, and the survivors made their way back home to the arms of their loved ones.

Sergeant DeWitt Clinton Guy followed the lead of his fellow prisoners; however, he did not return to his family in Lynchburg. He made his way north to Ogden, New York. It appears that before his father's death, while the family was moving from town to town, a special girl captured

the heart of a young DeWitt. After the war, he returned to capture her hand. The two courted, and DeWitt Clinton Guy and Martha Flagg were united in marriage.

After the wedding, the young couple settled in Lynchburg to raise a family. DeWitt became a partner in a local grocery store, Bigbee, Guy and Thaxton. He was also a member of the local Masonic lodge. For a while, the Guy family trail goes cold. However, according to an 1880 census, Martha and DeWitt still lived there with their seventeen-year-old son, Harry.

DeWitt Clinton had a Confederate's heart until the very end. On his deathbed in 1889, even after the war was long over and lost, he still claimed to be part of "Jefferson Davis's Confederacy." In his obituary, published in the *Lynchburg Daily Virginian* on January 7, 1889, DeWitt was "true to his colors and never apologized for the part he took in the lost cause." At the age of forty-seven, he was laid to rest at Spring Hill Cemetery. Martha was brokenhearted and returned to her family in New York. She lived out her days in Ogden until her death in 1891, just two years after her husband. Martha and DeWitt would not be apart for long. Soon after his wife's death, his body was exhumed and buried beside her at Fairfield Cemetery.

The family Bible that he carried in to battle was donated to the Lynchburg Museum in November 2010 by his great-great-grandniece, where it is on display to share his story as a Confederate soldier. Until recently, in New York, a Confederate reenactor stood vigil at his grave each Memorial Day.

6
Hamlin CCC Camp/POW Camp

The test of our progress is not whether we add more to the abundance of those who have much; it is whether we provide enough for those who have too little.
—*Franklin D. Roosevelt, second inaugural address, January 20, 1937*

In the 1930s, the Great Depression hit the United States with a powerful blow. The bottom fell out of the economy, businesses failed and thousands, if not millions, were out of work. Families were ripped apart; children were sold or left at orphan asylums to become wards of the state. It was a heart-wrenching time that was felt most heavily by the poor and middle class. We get a true feeling about what the typical American family looked like though classic photographs depicting the dirt-covered faces of children standing beside their exhausted and worry-worn parents. Whoever said that a picture is worth a thousand words could not have been more right. The Depression hit hard in Rochester, but it was not as bad as in other cities throughout the country. The banks remained open, but dividends were cut. Clothier Hickey-Freeman cut the hours of its employees; however, they all kept their jobs. Rochester had the soup and bread lines; they were just shorter than those in other areas.

Local governments gave as much as they could to those who needed it, but it became apparent that it was time for the federal government to step in and step up. President Franklin Delano Roosevelt created the New Deal, which established a number of programs and laws that were meant to bring the country out of the Depression. The main objectives of the New Deal

were the three Rs: It was to create jobs to relieve the poor and unemployed, which would in turn help recover the economy. The program also mandated a series of regulations that would reform the country's financial system in order to prevent another depression from happening again.

The Civil Conservation Corps (CCC) was one program that provided relief for the poor while rebuilding the infrastructure of America. Young men who were unemployed, unmarried and between ages seventeen and twenty-eight could enlist in the CCC for anywhere from a six-month to a two-year commitment. In return, they were fed, given housing and provided medical care while earning a healthy wage to support their families. Each man made $30 per month, which is equivalent to $540 today, and $25 must be sent home.

In Hamlin, Civil Conservation Corps Camp No. 1252, or Moscow Road Camp, opened in May 1935. The camp housed 200 men at the time; over six years, more than 1,600 men went through the program there. The project at the camp was to turn the small county park into the beautiful state park that it is today. The CCC enlistees built Hamlin Beach State Park with their own hands. All the work was done on site; lumber was cut and milled at the camp, and the stone was cut into the blocks needed for the construction. The pavilions, snack bar, bathrooms and water fountains were all made by the men, who used Medina sandstone and locally harvested lumber. They constructed sidewalks and break walls, as well as the park loop road. Creating a 1,200-plus-acre park was a daunting task, but being able to earn a living for their families was worth it. Across America, thousands were doing the same.

As our allies entered World War II, they needed war materials. Factories were reopened and retooled to make anything that might be needed on the battlefront. Manufacturing plants had to run seven days a week. That meant jobs, lots of jobs, and high-paying jobs. While the CCC camps served their purpose well, the country had new needs to fill, especially now that the world was at war. The Moscow Road Camp closed in August 1941.

When the camp closed, a handful of buildings were dismantled. The rest remained intact, ready and waiting for the next adventure—and what an adventure it would be. All of the able-bodied men were either working in the factories or had enlisted in the military. Local farmers were shorthanded for help. The camp was used for a brief time to house migrant workers from the Bahamas, who were hired by the farmers to work in the fields. The last group of Bahamians left the camp in the summer of 1943.

Japanese pilots bombed Pearl Harbor on December 7, 1941. At the time, the United States was not looking for a fight, but the fight had come looking for us. As a result of the attack on Hawaii, the country joined the Allies in the fight against the Axis powers (Japan, Germany and Italy). For years, the fighting raged on in the Pacific theater and on the European continent. The Allies took their captured enemies as prisoners of war and sent them to detention camps all over the world. When Italy surrendered to the Allied forces, the U.S. Army generals sent their prisoners of war back to the States. In September 1943, 110 Italian prisoners arrived at the former CCC camp in Hamlin. Their stay was brief. A month later, on October 13, 1943, Benito Mussolini switched his allegiance and became an ally of the United States. With that, the prisoners were released and sent back home to Italy.

Not too long after the Italians returned home, new "guests" arrived at the camp, and the reception was not as warm. The German prisoners of war arrived on June 30, 1944, and everything was ready for them. As they were believed to be a much greater threat to the local population, an eight-foot barbed-wire fence with guard towers was erected, and outdoor lights and searchlights were installed. Single cots in the barracks were changed out for bunks, doubling the camp capacity. Depending on the time of year and the demand for labor, the population of the camp fluctuated. In the fall of 1945, the camp held its highest number of POWs, 452 prisoners. The barracks were filled to the brim, and seventeen tents had to be pitched to accommodate the overflow. If German soldiers were captured, they were glad to be sent to a camp in the United States, because living conditions were better in the POW camps than on the front lines with their troops. They were guaranteed plenty of food and water, as well as protection from the elements.

Prisoners at the camp were put to work on farms and in processing plants to keep operations going for those at home while the boys were off to war. According to the Geneva Convention, prisoners could only be made to work if they were paid, so the men received a small stipend. Under heavy guard, they became a curiosity for the locals. Children in the nearby town of Hilton would often ride their bikes to the packing plant just to watch them work and hear them talk. The German prisoners would sometimes give the boys money to buy cigarettes and chocolate for them. Not once was it documented that a prisoner caused any trouble, and the locals began to see them as just human beings.

The camp in Hamlin was not the only one in the area. There was a much smaller camp at Cobb's Hill in the city of Rochester. As with Hamlin, it

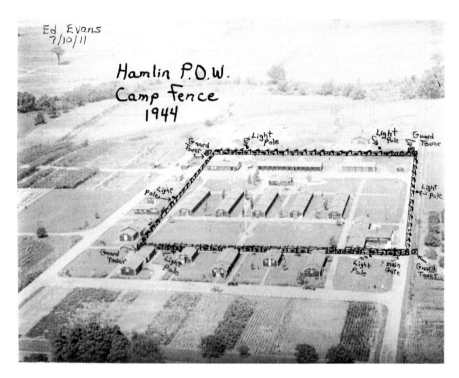

Map of the POW camp in Hamlin in 1944, also the site of a former CCC camp. *Friends of Hamlin Beach State Park.*

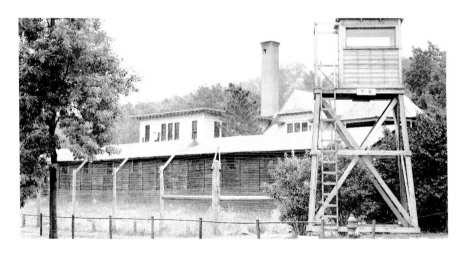

Guard tower and barracks at the POW camp at Cobb's Hill Park in Rochester, 1944. *Rochester Public Library.*

housed Italian prisoners in September 1943 and one hundred German prisoners of war in the summer of 1944. At first, the city residents near the camp were afraid of what would happen if the prisoners escaped. Colonel John McDowell, who was in charge of the prison camps, advised civilians to treat the Germans "with respect and not as jail prisoners." Over time, they became comfortable with them being there and enjoyed the sound of their music drifting on the evening air. In August 1944, two hundred Rochester residents clashed with the American soldiers guarding the camp. The citizens had gathered on the field outside the camp to listen to the Germans sing, and the soldiers became offended by the applause given to the prisoners. The police were called to disperse the crowds. This was an account from the August 14, 1944 *Times Union*: "Fist fights started. Joseph Sauer and his son, Frederick, were beaten up by the soldiers. [When police arrived at the scene] Mrs. Sauer was swinging her pocketbook at a soldier." Even after the confrontation with the soldiers, people continued to gather on the field, and the American soldiers grew increasingly short-tempered. The city tried to diffuse the situation, unsuccessfully. Then the Rochester government officials petitioned the military leadership to close down the camp at Cobb's Hill. That request was denied, but civilians were prohibited from having any interactions with the Germans interned there. There was little excitement at the Hamlin camp in comparison to the one at Cobb's Hill. However, there are witness accounts of a guard going crazy one night in the tower, firing his machine gun toward the lakeshore in the dark.

World War II came to an end on September 2, 1945, and the prisoners were eventually released. Many of them, after returning home to Germany, brought their families back to the United States and became U.S. citizens. The Hamlin camp closed for good in January 1946. The army dismantled all the buildings, and the grounds were reclaimed by nature. For over sixty years, it remained hidden, until the Friends of Hamlin Beach State Park began clearing it out. The group has recently erected informative signs all over the site so that visitors can take a self-guided tour and learn more about the camp's history.

7
THE LOOMIS GANG

The Loomis family, known as the Loomis Gang, was a nineteenth-century band of outlaws that lived in Sangerfield, near Nine Mile Swamp, a seven-thousand-acre swamp along the Chenango River. The first Loomis in America was Joseph Loomis, a wool draper from Essex, England. In 1638, he arrived on one of the first ships to come to the new colonies, settling in Boston, which at the time was part of the Massachusetts Bay Colony. Eventually, he moved to Connecticut. The first generations of the Loomis family were well respected, serving their communities as lawyers, doctors, ministers, scientists and teachers. Somewhere along the way, the family got off the path of righteousness.

George Washington Loomis was the patriarch of the Oneida County, New York branch of the family. George was a respected and well-liked farmer. He was educated and popular; his neighbors often sought out his advice and put great stock in his opinions. George used this public reverence toward him as a smoke screen to hide his true nature. He was born in 1799 in Windsor, Connecticut. When he was only five, his mother died. When he was nineteen, he moved to Vermont to live with his sister. The following is an interesting excerpt from his biography on findagrave.com. It provides insight into his life of crime, which began when he was a young man:

> *He had a fondness for horses and a predilection for collecting those that did not belong to him. He learned early that stolen horses could easily be driven to Connecticut and sold with no questions asked....In 1802 he fled*

Randolph, Vermont just ahead of the sheriff's posse and headed towards his sister Clarissa Loomis Preston's home in Sangerfield, Oneida County, New York with over $3000 in gold coins in his saddlebags.

Rhoda Mallet (the future Mrs. Loomis) was a smart woman, employed as a schoolteacher. She was often described as "the belle of the ball," but with a fiery temper. Unlike George W. Loomis, her transgressions were handed down to her from her father, Zachariah Mallet. Troubles with money seemed to plague Rhoda's father. He had accrued so much debt that the sheriff came calling to collect. Either Mallet would have to give some money to the sheriff to pay against the debt or go to jail. This particular incident happened before George and Rhoda's marriage—it is said that it was the reason that George wanted to take her for his bride. When the sheriff arrived at the house for her father, Rhoda would not let him in. As the sheriff tried to enter the house by crawling through an open window, she hit him in the head with a shovel from the fireplace. George responded, "A girl that will fight for father will fight for husband. I am going to marry that girl." Whether this story is true or simply part of the Loomis legend will never be known. Rumors, however, seemed to follow Zachariah. It has been said that Mallet spent some time in prison for forgery and counterfeiting. Prison records from the earliest years of the nineteenth century are far from complete; therefore, for now, it will remain a rumor. It is a known fact that Zachariah Mallet failed to pay his taxes, and his property was seized as payment, according to Oneida County sheriff documents. Also, the *Little Falls Courier Journal* published a piece reporting that he was sent to Auburn State Prison in 1812 for the crime of perjury.

After her father's unfortunate incarceration, George and Rhoda were united in marriage and made their home near Nine Mile Swamp. Together, they had ten children, four daughters—Calista, Charlotte, Cornelia and Lucia—as well as six sons (in order of birth)—William W., Washington W., Grove, Wheeler, Amos and Hiram Denio. As the children grew up, Rhoda made sure that they were well educated, book smart. The children, even the boys, were well behaved and polite, taking on the persona of their father. Washington was a carbon copy of George Washington Loomis. This is an excerpt from the *History of the Loomis Gang* (1877), by Amos Cummings, about Washington:

He was a keen observer of human nature and seemed endowed with magnetic power. Few could resist the fascination of his manner and conversation.

Detective Wilkins says that in ten minutes he could turn an enemy into a friend. He was a born diplomatist, and never resorted to physical force when his ends could be obtained in any other way.

Rhoda also took great care in teaching them the ways of a criminal mind. There are accounts of her life that have Mother Loomis telling her children that "you may steal, but if you are caught, you shall be whipped." She would also tell them, "Now, don't come back without stealing something, [even] if it's nothing but a jackknife." Only her sons attained lives of crime and intimidation. Three of the girls married into respectable families; the fourth remained at her mother's side until Rhoda's death.

Around 1820, when the children were young, some still babies, a traveling peddler went missing. The last place that he was known to have been was the Loomis farm. Even though the sheriff did not have a search warrant, the family allowed him to look for the peddler on their farm. As the sheriff looked for clues that might point to what happened to the peddler, he became suspicious when he found a well that was filled with stones. The sheriff and his men began pulling the stones from the well in hopes of finding the peddler's body or whatever else was hiding at the bottom of the well. About halfway down, they found a boulder that was too large to move, and that was the end of their search. Someone went to great pains to cover up something. Could the Loomises have gotten away with murder? The answer will forever lie at the bottom of that well.

When the Loomis sons were older, they stole horses and livestock. But they didn't limit themselves to livestock. They traded in stolen goods, burglarized homes and businesses and passed counterfeit bills. Dealing with counterfeit money was something with which George W. Loomis was all too familiar. George was almost sent to prison before he married Rhoda for doing just that. Counterfeiting was a blight on the country; the fake money flooded banks and the marketplace. The law believed that bands of counterfeiters used the Loomis house as a meeting place. George was even caught red-handed with a fake $100 bill. He was able to buy his way out of the charges like he had done so many other times, while his accomplices were sent to prison.

Now as for his sons, even though they were criminals, their mother made certain that she raised smart criminals. The Loomis boys never stole from anyone who lived near them, nor did they keep stolen property at the farm, even though, when the homestead was built in 1825, it had double-paneled walls and false floors. Everything was hidden in Nine Mile Swamp, because

Rhoda M. Mallet Loomis, matriarch of the Loomis family. The Loomis gang was the largest family crime syndicate in America during the 1860s. *Waterville Historical Society.*

very few people other than the Loomises could find their way in and out of the quagmire. The reasoning behind this strategy was brilliant. Their neighbors would never suspect the Loomis family of the thefts. In fact, neighbors would often ask for their help in finding whatever was taken, and in some cases, the boys even joined posses. The Loomises would be more than happy to help. With the stolen goods stored elsewhere, the crimes could not be linked to them.

Those who suspected the Loomis family of a crime and spoke out about it were met with swift retribution. It was not uncommon that soon after someone talked to authorities, a house or barn would mysteriously be destroyed by fire. And, of course, the Loomis men had airtight alibis. In the off chance that the sheriff showed up at the door with an arrest warrant, the charges were almost always dropped. Generous bribes were paid to judges, and evidence disappeared, making prosecution impossible.

A combination of fed-up neighbors and complacency on the part of the family almost led to the undoing of the Loomis Gang; the second time, the family would not be so lucky. In 1849, a posse of local men were able to get a search warrant and raided the farm. The boys had broken their own rules; they stole from their neighbors and did not hide the stolen property in the swamp. The posse found twelve wagons loaded with things that belonged to the Loomises' neighbors. Even though they were caught with "their hands in the cookie jar," the charges brought against them did not stick. Once again, they avoided jail. This was too close a call this time. Washington, George and Rhoda's second-oldest son, felt that it would be a good idea if he left town for a while and headed west to join the gold rush in California. With Washington's brains and charm, he was pretty much the head of the Loomis Gang. His departure was a blow to the family, and an even bigger blow occurred during his absence when George died on February 26, 1851. With both their father and the leader of the gang gone, there was no guidance, and the family took a break from the life of crime.

Washington's luck ran out in California, and he came back home. With his return, the gang was back in business, and they picked up right where they had left off. It was as if Washington had never left. While he was in California, the country was thrust into the Civil War. The Union army was in need of fresh horses, and the Loomis Gang was good at getting their hands on some. They quickly began stealing horses from nearby farms and selling them to the government. During the Civil War, there was a shortage of lawmen; they had all enlisted and were fighting battles in far-off places. This gave the Loomis Gang free reign, and they became the largest family crime

syndicate in America. Indictments against the Loomis Gang were secured and sat in the Morrisville County Courthouse. On October 10, 1864, the courthouse burned to the ground, supposedly by Washington Loomis. This was the beginning of the end for the Loomis Gang. It would soon come crashing down around them.

At the end of the Civil War, the fighting men returned home and refused to bow down to the Loomis family any longer. The gang's known associates were picked off one by one and brutally attacked. Then, in the middle of the night on October 29, 1865, the Sangerfield Vigilante Committee, a group of angry men led by a local constable, descended on the Loomis farm. With a knock on the door, Washington was called outside and ambushed. His body was later found behind the woodshed; his skull had been bashed in. During the raid, Washington's brother Grove was also attacked. He was beaten, covered in a burlap sack soaked in kerosene and set on fire. As his sister Cornelia beat out the flames and saved his life, the barn burst into a raging inferno. Within a matter of an hour or two, the Loomises' forty-five-year reign of terror had come to an abrupt end. Just to make sure the family had a clear picture that the community was done with them, the farm was raided again a year later and the house was burned down.

It was said that in Washington Loomis's last breaths, he cursed the family land with death to anyone living there who did not have Loomis blood running through their veins. The other boys, with the exception of Denio, scattered across the country. Rhoda lost what was left of the farm to the tax assessor. She, Cornelia and Denio moved to Hastings, New York, some seventy miles north of Syracuse. The old Loomis homestead is a few yards off the corner of Swamp and Loomis Roads south of Waterville. This house burned long ago; all that remains of the farm is the foundation of a barn. The legacy of the Loomis family has become legend.

8

BIRTHPLACE OF MEMORIAL DAY

The Civil War was, by far, the deadliest war in which the United States has been involved. What made it worse was that it was fought on our own soil, with brother against brother, neighbor against neighbor. For four long years, men were hundreds of miles away from their families and homes. After the war was finally over, the soldiers returned home to people waving flags lining the streets and marching bands playing military stanzas. While the living got a hero's welcome, the dead lay silent on distant fields or slipped into town by rail in a freight car, greeted only by the sorrowful tears of their loved ones.

Henry C. Welles, a druggist in Waterloo, New York, thought that instead of celebrating only the living war veterans, those who served and died for their country should be honored as well. Although the idea was a noble one, it did not come to fruition until he joined forces with General John B. Murray. Murray was an officer in the 148th Regiment of the New York Volunteers who moved to Waterloo in the fall of 1865 after the war ended. Even though his military career was over, he continued to serve his community as the Seneca County clerk. Murray was forever the patriot and joined the Grand Army of the Republic (GAR), an organization of Civil War veterans who fought for the Union. Together with Welles, they headed the Decoration Day committee. The festivities were held on May 5, 1866, and the entire town embraced the celebration. According to the *Summary of Other Claims Regarding the Origin of Memorial Day* (1965–66), "The townspeople adopted the idea wholeheartedly. Ladies of the village

General John B. Murray, along with Henry C. Welles, organized the first Memorial Day celebration on May 6, 1866. It was the beginning of what would become a national tradition, earning Waterloo the moniker of the Birthplace of Memorial Day. *New York State Hall of Governors.*

met at a local hall and prepared wreaths, crosses and bouquets for each veteran's grave."

It was a Victorian spectacle to behold. On the day of the parade, all of the businesses in town were closed, porches and windows in Waterloo were decorated with evergreens and black buntings and all the flags were flown at half staff. Civic groups marched down Main Street alongside veterans as bands played martial songs. At the three town cemeteries, the grave of each fallen soldier was adorned with wreaths and flags. According to an unidentified newspaper at the time, "Impressive and lengthy services were held at each cemetery including speeches by General Murray and a local clergyman." The celebration took place again one year later on May 6, 1867.

Word of Waterloo's Decoration Day celebration reached General George John Logan, the national commander of the Grand Army of the Republic. Logan issued GAR General Order No. 11, which created a national day to honor the military dead. The order reads, in part:

The 30th day of May 1868, is designated for the purpose of strewing with flowers otherwise decorating the graves of comrades who died in defense of their country during the late rebellion, and whose bodies now lie in almost

For 151 years, the town of Waterloo has been celebrating Memorial Day. For the 150th celebration, reenactors dressed in period clothing from the late nineteenth century. *Robert Parker.*

every city, village and hamlet churchyard in the land....Let us then, at the time appointed, gather around their sacred remains and garland the passionless mounds above them with choicest flowers of springtime; let us raise above them the dear old flag they saved from dishonor.

For Welles, he could not have been prouder to have his Memorial Day become a national celebration, even though Murray and Logan were given the credit. Four months after Logan's order, Welles passed away, leaving behind his patriotic legacy.

Several towns claim to be the birthplace of Memorial Day. On May 26, 1966, President Lyndon B. Johnson signed Proclamation 3727-Prayer for Peace, Memorial Day, 1966, giving the honor to Waterloo:

By House Concurrent Resolution 587, the Eighty-ninth Congress has officially recognized that the patriotic tradition of observing Memorial Day began one hundred years ago in Waterloo, New York. In conformity with the request contained in the concurrent resolution, it is my privilege to call attention to the centennial observance of Memorial Day in Waterloo, New York, on May 30, 1966.

Welles would be even more proud to know that in 1971, a law was signed making Memorial Day a federal holiday. As of this writing, the citizens of Waterloo have celebrated this day of remembrance for 151 consecutive years.

9
MURDER OF CROWS

Gathering at dusk, crows land in a tree, then scuffle and squawk…filtering down through the branches. Crows stream by overhead in the late afternoon—rivers of crows. These are crows with a purpose.
—*Ellen Blackstone*

One of the greatest phenomena in the animal kingdom is the roosting of crows, as many as twenty to forty thousand in one communal group. According to scientific research, a roost is often used for several years before the birds move on. During the day, the crows spread out all over the countryside to eat, coming to staging areas throughout the day, but go to the roost only as dusk begins to fall. Cemeteries are perfect staging areas, because they are fairly open and are a plentiful source of food. Auburn's Fort Hill Cemetery has been a staging area to thousands of crows for decades, much longer than normal and to the confusion of scientists. Why do they keep returning year after year? Many believe that there is a spiritual meaning as to why, linked to the Native American roots of the land.

Fort Hill Cemetery is one of the highest points in Auburn. The reason for its high elevation goes back almost one thousand years. Before it was a cemetery, the hill and the land surrounding it had quite a Native American history. Within the confines of Fort Hill is the Osco Temple, a prehistoric Indian mounding from around AD 1100. The temple was an ancient fortified village used by the Cayuga Indians to protect the tribe when opposing tribes went to war. It was used until the early eighteenth century, when the Iroquois

Confederacy was formed. The confederacy forced the Cayuga to find a new home. For six hundred years, the Cayuga lived there, and a patch of land near the summit was used to bury their dead. When the Indians left, their dead remained behind.

One of the most notable Native Americans who once called Auburn home was John Logan, also known as John the Orator. Logan was the son of the great Chief Shikellamy. When war and disease threatened the Cayugas, they continued west into Ohio with the Seneca and Lenape tribes. They joined forces and formed the Mingo tribe. Logan, like his father before him, believed in maintaining friendly relationships with the settlers. And they all lived in relative harmony until the Yellow Creek Massacre in April 1774. In the massacre, the "Virginia Long Knives," British colonists from Virginia, murdered a number of Mingo, including Logan's brother. Although tribal chiefs called for a peaceful resolution, tradition in the Native American culture promoted retaliation for the killings. Raids by warrior parties sparked Dunmore's War. With only one major battle in the war, one that did not end in their favor, the Indians were forced into a peace treaty. Logan refused to attend the negotiations for the treaty; instead, he gave the famous speech that would be forever known as Logan's Lament. After he gave this speech, not much is known about his life, except that he was murdered by his own nephew near Detroit in 1780. In Fort Hill Cemetery, there is a fifty-six-foot obelisk dedicated to Logan. It is inscribed with the last line of his lament, "Who is there to mourn for Logan?"

As for the crows, they have many links to the Native American culture and spiritualism. Birds, in general, are believed to be messengers of the soul that deliver messages between the earth and sky. According to folklore, crows were the symbols of wisdom, the wisest of all the animals in creation. Not only were they wise, but crows also symbolized war. Mason Winfield said it best in his book *Iroquois Supernatural*: "Battlefield birds are everywhere associated with war and destiny. They know where death is soon to be found and where the bodies are to be had. In their visits with the eternal, they inquire the fates of heroes. They know the ends of empires."

Perhaps the crows have gathered there for so many years because the mounds of the Osco Temple are sacred grounds of which the crows are the guardians. Or maybe the crows are the ones there to mourn for Logan. Is the answer to the crows gathering at Fort Hill scientific or purely spiritual?

10
NATIONAL EXCHANGE

According to the National Park Service, when the Erie Canal opened in 1825, it revolutionized trade, commerce and transportation. It opened up the western frontier to the more industrialized Atlantic Seaboard. After the success of the Erie Canal in its first decade, other canals were built to tie into it and further open trade and the economy. In 1836, eleven years after the Erie Canal opened, construction began on the Genesee Valley Canal, which connected the Erie Canal to the Allegheny River in Olean, New York, so that goods could be transported between Rochester and Pittsburgh. As with towns on the mighty Erie Canal that grew from the business that the canal brought, the same was true for those on the Genesee Valley Canal. Some towns, however, were not built because of the canal; Cuylerville was one.

Cuylerville was first the site of Little Beard's Town, or Chenussio, a powerful Seneca Indian village. Chenussio was destroyed by Washington's army as part of Sullivan's Expedition in retaliation for the brutal torture of Lieutenant Boyd and Sergeant Parker at the hands of a renegade ambush party in 1779. Cuylerville was incorporated in 1848, but the settlers moved on to the land shortly after the smoke cleared and the surviving Indians from the destruction of Little Beard's Town were moved to a reservation.

The National Exchange, presently the National Hotel, was built in 1837 by Charles Phinney—before the Genesee Valley Canal opened at Cuylerville in 1840. Prior to the coming of the canal, a stage route ran directly in front of the inn, bringing travelers to its doorstep twice a week. As it was at the

crossroad of the stage road and the Genesee Valley Canal, the business opportunities were numerous. The National Exchange benefited greatly from travelers needing a place to eat and sleep.

A different type of person rode the stage, as opposed to those working and traveling on the canal. The captain and his crew were hired based on their reputations for being able to get the job done. Competition for freight contracts was fierce, so the toughest and most ruthless men got hired first. Police blotters, as well as newspaper columns, were filled with reports of fights and sometimes murders at the docks and in canal-side taverns. A drunk canaler was a dangerous canaler. The following story—part of which happened at the National Exchange—has been handed down over the years in Cuylerville:

> *The first boat to be pulled down the canal when it was opened on September 1, 1840, from Rochester to Mount Morris was piloted by Bucko Ben Streeter, known as the Terror of the Valley and the Rochester Bully. He had recently fought for a straight hour in the old Rochester Reynolds Arcade with a black man named Sleepy Frank. On the second boat pulled in the Cuylerville Basin in front of the hotel was Bucko Ben's old opponent Sleepy Frank. "Let's get this damn thing over with," yelled Bucko Ben, and he stripped to the waist. The only rule was that the loser was to buy five rounds of drinks for the house. The fight began in the hotel bar and ended in the horse stables, lasting two hours, and it was Bucko Ben who bought the drinks. He never returned to Rochester, sold his boat and became a law-abiding citizen of Cuylerville.*

Phinney entrusted the National Exchange's operation to Truesdale Lamson in 1843. Lamson was a staunch abolitionist, so it was no surprise that the hotel became a stop on the Underground Railroad. The attic and stairwell were the perfect hiding places for the runaway slaves. At the height of the abolitionist movement, in 1848 alone, twenty-eight slaves found safety and refuge there. It is also rumored that James G. Birney, the 1840 and 1844 Liberty Party presidential nominee and a former slave owner, helped runaway slaves escape to freedom through the hotel.

Like many inns, hotels and taverns of the time, the Exchange played multiple roles in the community. The National Exchange was also Cuylerville's town meeting hall, boasting a visit from William H. Seward. Seward was a politician from Auburn who became secretary of state under President Lincoln. He survived an attack in his Washington, D.C. home

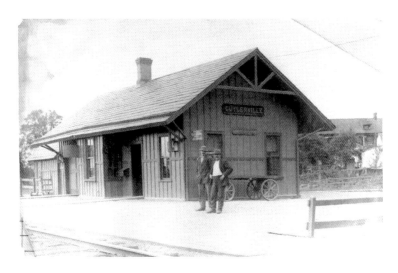

Train depot in Cuylerville across the street from the National Exchange. *Gatherings at the Depot.*

from Lewis Powell, a co-conspirator of John Wilkes Booth, the night that Lincoln was assassinated at Ford's Theater.

Within ten years, Cuylerville had become an important stop on the Genesee Valley Canal. The town had grown to support several stores and warehouses. Farmers in the area to the west and south brought their produce to Cuylerville to ship from its port. As the town grew, so did the hotel. Truesdale Lamson moved on, and Phinney turned the management of the National Exchange over to William Scoville in 1850. Increased traffic, both on the canal and by stage, continued to bring more business to the area, especially to the hotel. The National Exchange's proximity to the canal basin, less than fifty yards, meant that there was never a shortage of clientele. The National Exchange still wore many hats. In the mid-1850s, whiskey was distilled on the premises, while William B. Wooster taught Sunday school classes there.

The canal eventually closed in 1877, unable to compete with the railroads that began to crisscross the country. The town and the hotel took a huge hit. By the end of the 1800s, the government of Cuylerville was dissolved, and it became a hamlet of Leicester. Subsequently, the canal towpath was sold to the Pennsylvania Railroad, which built a branch on it. With the closing of the Genesee Valley Canal, the National Exchange was down, but it was not out. Its saving grace was that the railroad put the rail station directly across the street.

When the Sterling Salt Mine opened in 1906, Cuylerville once again became a boom town. Immigrants, mostly from Italy, began streaming in. The National Exchange became a boardinghouse for many of the families. In the 1920s, the hotel was the center of a bootleg liquor ring in the area, according to newspapers like the *Livingston Republican*. Another paper reported that in August 1925, a large amount of illegal alcohol was found during a raid by the police. The locals contend that the National Exchange was a speakeasy during Prohibition and had possible ties to the mob.

Cuylerville's rebirth was short-lived, as the mine closed down in 1930, only twenty-four years after it opened. The National Exchange tried to stay in business as long as possible. There was less travel by train with the growing popularity of the automobile. For awhile, the business from motorists out for a drive sustained the hotel, but barely. When gasoline was in short supply in World War II, even those patrons disappeared. The doors had to close—but not for long.

Construction began on the Mount Morris Dam in 1948. The hotel had a reason to reopen: engineers and out of town construction workers needed a place to eat and sleep. In the early 1950s, renovations were made, and the Exchange was renamed the National Hotel. The country saw an economic upturn, and once again, the venue became a destination because of its reputation for fine dining. After 167 years, the National Hotel was listed in the National Register of Historic Places in 2004. It has been a few decades since patrons could stay the night in the hotel, but the dining room is still open.

II
ONONDAGA

When talking about lake navigation and the shipping industry in American history, one automatically thinks about the huge freight liners silently slipping through the water of the Great Lakes. We tend to forget that not too long ago, the world was a much smaller place. A one-hundred-mile trip then was just as daunting as a one-thousand-mile trip is today. The big ships of the nineteenth century not only traveled on the Great Lakes but also traversed the smaller lakes, such as the Finger Lakes of New York State. And just as with the Great Lakes, many ships rest on their sandy bottoms as well. Such is the case with Seneca Lake.

Travel on Seneca Lake is centuries old, going back to the Native Americans who lived along the shores before the settlers arrived on the continent. With a history that long, it is a given that scores of vessels have made the lakebed their final resting place. A couple of ships in the graveyard stand out from the others. Notably, the steamship *Seneca Chief* (also called the *Geneva*) and the *Onondaga* call the icy depths of the lake home.

The *Seneca Chief* was built in the late 1820s and was the first steamboat on Seneca Lake. It came about twenty years after Robert Fulton built the *Clermont*, the first steamboat to successfully run on the East River off Greenwich Village in New York City. The Rumney brothers, Geneva businessmen, saw the future in Fulton's steam-powered ship engine and

had the *Seneca Chief* built to corner the market for steam navigation on the lake. It was a good-sized boat for the time, with a keel ninety feet long, nineteen feet wide and eight feet high. An 1828 article in the *Geneva Gazette* noted the *Chief*'s powerful forty-horsepower engine, which could travel at a speed of ten to twelve miles per hour. A trip from Geneva south to Watkins Glen, which was at the head of the lake, only took five hours, less than half the normal travel time. This was the route for the *Seneca Chief*'s maiden voyage. The steamboat was launched in May 1828, but its first trip was made during Geneva's Independence Day celebrations. It took off for Watkins Glen at eight o'clock in the morning with a crew, about 130 passengers and a band. After spending a couple hours at the Glen, the *Seneca Chief* returned to its home port at about eight o'clock that night. A reporter wrote that the *Seneca Chief* had made "next door neighbors" out of those at the south end of the lake, "that hitherto remote region."

The maiden voyage was *Seneca Chief*'s only pleasure cruise; it was built for work. The boat made daily trips to Watkins Glen six days a week. An article in the *Courier* detailed its purpose:

> *Immediately after the Fourth the Steam Boat will commence her regular trips to the head of the Lake daily, Sundays excepted, leaving Geneva at 7 in the morning and returning at 7 in the evening—carrying the mail in connexion with a daily line of stages to Washington City. She will touch at Dresden and Bailey town (near Ovid) to receive and deliver passengers and take freight boats in tow.*

There is one account of the *Seneca Chief* pulling into the port of Geneva with ten boats in tow with cargoes of flour, pork, whiskey and lumber. It was a workhorse. Within a year, the Rumneys revamped the *Chief*, raising its engine three feet. The brothers also added a luxury cabin and a mast to take advantage of the fair winds that tended to grace the lake. The changes increased the boat's speed and improved the *Seneca Chief*'s appearance and accommodations.

A winter storm in January 1832 put the *Seneca Chief* on the lake bottom right at the spot it was moored at the dock. When the steamboat was raised that spring, it was discovered, to everyone's surprise, that damages were minor. Soon, the *Seneca Chief* was back in business. Although the *Seneca Chief* received only praise, and it had always been profitable for the owners, the Rumneys sold their boat in 1833 to John R. Johnston and Richard Stevens. After they bought the *Seneca Chief*, the partners also purchased all

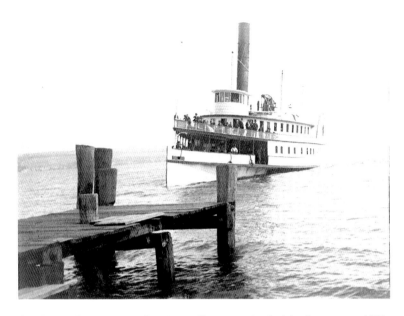

The Seneca Lake steamer *Onondaga* pulling up to the dock in Geneva, pre-1895, before its destruction in 1898. *Geneva Historical Society.*

the rights to steamboat navigation on Seneca Lake. The ship was again overhauled; the new owners added another thirty-five feet to the keel and renamed it the *Geneva*. The *Geneva* would prove to be very profitable for Johnston and Stevens.

The life of an early lake steamer was relatively short. By 1847, after only twenty years of service, the *Geneva*'s usefulness had come to an end. Instead of having it rot in the boatyard, it was decided to make the *Geneva*'s destruction part of the city's Independence Day festivities. The *Seneca Chief* made its debut on the Fourth of July, so it was only fitting that the *Geneva* said its goodbyes on the same day. In 1889, the *Geneva Gazette* recapped the events of the day.

> *It was to be the grand coup of the celebration. Loaded with a supply of powder she was placed far out in the lake, and a wire connected with an electric battery to run her. A grand spectacle was looked for by the assembled multitude on the shore. It is estimated that ten thousand people were present lining the shore at every convenient point. The electric key was touched time and again but there was no thundering response. Failing*

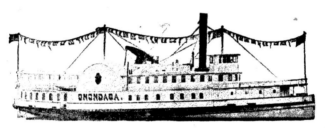

Flier advertising the blowing up of the *Onondaga*. The event on September 14, 1898, drew thousands of spectators. *Geneva Historical Society.*

in this a party armed with a fuse was despatched [sic] *in a small boat and another attempt was made to blow her up by thus igniting the powder. This even failed to work, but the boat took fire and the disappointment of the spectators was considerably lessened by seeing the relic of the grand old steamer shoot fiery tongues towards the Heavens, illuminating the harbor and the adjacent shores....The powder had become wet in some manner and its explosive qualities thus destroyed. As it was the sight was memorable one.*

Thirteen years later, the steamer *Perez H. Fields*, named after the New York assemblyman from Ontario County, was built in Geneva in 1860. Made to serve as a tow boat, it was 175 feet from end to end with a paddle wheel on the side. This made it one of the largest lake steamers at the time. During the Civil War, the *Perez H. Fields* was called to duty as a transport ship. Hundreds, maybe thousands, of enlisted Union soldiers gathered in Geneva on Seneca Lake's northern shore. These men boarded the *Perez H. Fields* to cruise down the lake to Watkins Glen, where they would travel the remaining twenty-four miles to the Union camp at Elmira and then on to the battlefields of the South.

In 1870, shipbuilder Bruce Springstead began to remodel the steamer for the Seneca Lake Navigation Company. He was commissioned to transform it from a tow boat into a grand passenger steamer. When the ship was reinstated, it was christened the *Onondaga*. A long list of changes was made, including the addition of luxurious staterooms and a dining room that could accommodate up to five hundred passengers. The *Onondaga* could make the trip from Geneva to Watkins Glen in just three hours, which was by far the fastest travel time for the day.

For thirty-five years, the *Onondaga* plied a steady course from Geneva to Watkins Glen and to many points in between. Newer and faster ships came along, and the *Onondaga* was no longer the belle of the lake. It was not long before the newer ships took over its route running up and down the lake. Finally, in 1898, it was demoted to the role of a quarantine ship for a traveling troupe afflicted with smallpox. The Joshua Simkins Opera Company took the whole situation in stride, performing from the ship deck for those watching on the shore. But for the *Onondaga*, it was the beginning of the end, a death sentence. Four months later, the sentence would be carried out.

Handbills were handed out and posters hung around the area for hundreds of miles, advertising a spectacular event that no one should miss. The *Onondaga* was to be blown up to commemorate both the explosion of the USS *Maine* on February 15, 1898—off the coast of Cuba, which started the Spanish-American War—and the end of the war in August 1898. On September 14, more than five thousand people came to the shore of Seneca Lake. Trains made special trips from Rochester, Syracuse and Utica to carry passengers to see the *Onondaga* destroyed in a most spectacular way. Families arrived in wagons after hours on the dusty road. People picnicked, bands played and even a hot air balloon hovered overhead. The atmosphere was that of a county fair, all to see the sinking of the "Pride of Seneca Lake."

The *Onondaga* was towed out on the lake eight miles south of Kashong Point. Five hundred pounds of dynamite and three hundred pounds of powder were on board to ensure that it would go down without a fight. When the dynamite was detonated, the outcome was very different from that of the *Seneca Chief*. Witnesses claimed that a five-hundred-foot mushroom cloud erupted over the vessel, and pieces of the ship showered down from the sky. As the smoke cleared, a large piece of the *Onondaga*—in flames—remained on the surface. By morning, the great steamer rested at the bottom of Seneca Lake.

The *Seneca Chief* and *Onondaga* are the most famous wrecks on Seneca Lake, but they are by no means the only ones. Most of the boats that lie on the sandy bottom are anonymous. Just off the shore of Glass Factory Bay, south of Geneva, is another ship that met its demise on the waters of the lake. Mother Nature, not man, gave the lake this prize. On March 22, 1822, a winter storm blew across the lake. Gale-force winds caused the waves to become angry and visibility to disappear. In the bay, a schooner with a four-man crew aboard began to founder. The shifting cargo of lumber and furniture made it impossible to control the ship in the rolling waves of the storm. To keep from being washed overboard, the crew strapped themselves to the mast. Their cries for help carried on the winds and were heard on the shore. The townsfolk could not stand by while they slipped into a watery grave. Some men climbed into a boat, putting their own lives in danger, and battled the waves out to the schooner. The rescuers were able to bring all the sailors to safety to sail another day. However, the schooner lost its battle with the storm, broke apart and sank.

When you look out over the glassy surface of Seneca Lake on a beautiful summer day, try to imagine the graveyard of ship bones and, in some instances, the bones of crew members, that lay on the lake bed. And remember for every shipwreck that is recorded on the books, there are dozens more that are lost to history.

12
Rochester Orphan Asylum Fire

Although the almshouses across New York State opened around 1825 and provided housing and care for children and orphans, a group of Protestant women felt that children needed a safer place of refuge. At the almshouses, the children were forced to work instead of being educated. They were also vulnerable to the deviants who also called the county poorhouse home. The Female Association for the Relief of Orphan and Destitute Children opened in 1837 on South Sophia Street (present-day Plymouth Avenue), with nine children under its care. By the end of the first year, that number had grown to fifty-eight. The group was forced to find larger accommodations, as the two-story building quickly became overcrowded. The newly incorporated Rochester Orphan Asylum moved to a place on Corn Hill, but it was not suitable either. Money was quickly raised through donations from the community and allowed them to build a larger and more modern institution on Hubbell Park.

There were many reasons why a child was placed in an asylum. Obviously, if orphaned, but they were also left if they had a parent who was seriously ill, had a widower father who could not or would not care for them or if both parents were in dire financial straits. While the Rochester Orphan Asylum had orphans under its care, nearly three out of five had at least one living parent. In most cases, when parents and grandparents turned their children over to the orphanage, they had to pay $1.50 a week. That money paid for their room and board, food and

A sign marking the possible location of the Rochester Orphan Asylum before it was destroyed by fire. *Author photo.*

medical expenses. In fifty years, the need was so great in Rochester that there were at least four such asylums around the city. By the end of the nineteenth century, the Rochester Orphan Asylum alone took care of 109 children.

One of the worst tragedies in Rochester history happened on January 8, 1901, at the Rochester Orphan Asylum on Hubbell Park. Unbeknownst to Mr. Erhardt, the custodian, and the rest of the staff, someone had forgotten to close off the gas jet for the steam flat iron in the laundry room. For hours, natural gas filled the room and had begun seeping out from under the door. All the children had settled in bed for the night around eight o'clock, and the staff prepared to close the building for the night. When the eleven o'clock rounds were made, Sarah Ashdown thought that she detected the faint odor of gas but ignored it. Martha Gillis, who was in charge of the boys, locked the door between the boys' dormitory on the

east wing and the rest of the orphanage, just as she did every night. The actions of both women would prove to be fatal.

By 12:30 a.m. so much gas had seeped into the hallway that it was ignited by a gaslight, causing a small explosion and fire. Mr. Erhardt got the alarm for the fire, and within a minute, he was at the orphanage and found that the small fire had burned itself out. Moments after his arrival, a second explosion rocked the boiler room in the basement with such force that a plume of gas was propelled up into the conservatory on the first floor. Two men walking down Plymouth Avenue felt the concussion from the explosion and saw the smoke. They quickly went to the firebox on the corner to sound the alarm.

The explosions erupted into monstrous flames and thick smoke that caused screaming and panic throughout the building. The children and their caretakers were frantically looking for a way out. Some made it to the roof but were not near the fire escapes. Inside the building, many of the windows would not open. The rutted, muddy roads were beginning to freeze, making it difficult for the firemen to get to the asylum. One horse-drawn rig got stuck and overturned. By the time the fire department reached the blaze, within half an hour, the west wing of the building was a raging inferno, and it was beginning to spread to the rest of the asylum. Can you imagine arriving at the scene to see the soot-covered faces of children as young as two pressed against the glass and screaming for help?

Witnesses recalled that "the laundry room and engine room were a seething mass of flames in which nothing could live a moment." Firemen carried unconscious children, many of whom died in their arms. Children ran from the building to the blanket-filled arms of neighbors, who took them into their homes for the night. "Even the firemen, accustomed to such fire scenes, could in some instances, scarcely refrain from tears."

An unknown newspaper reported in an article the following day, "Soon after the flames burst forth, white figures could be seen frantically rushing from room to room, faces peering from the windows seeking some means of escape from the terrific heat and strangling smoke. Some fainted in plain sight of the heroically working firemen."

The *Democrat and Chronicle* reported, "A woman screamed that more children were still on the second and third floors; firemen, policemen and citizens hurried up and came back down with four or five children, all of whom were unconscious. They were taken across the street where some of them died. Others died on the way to the hospital."

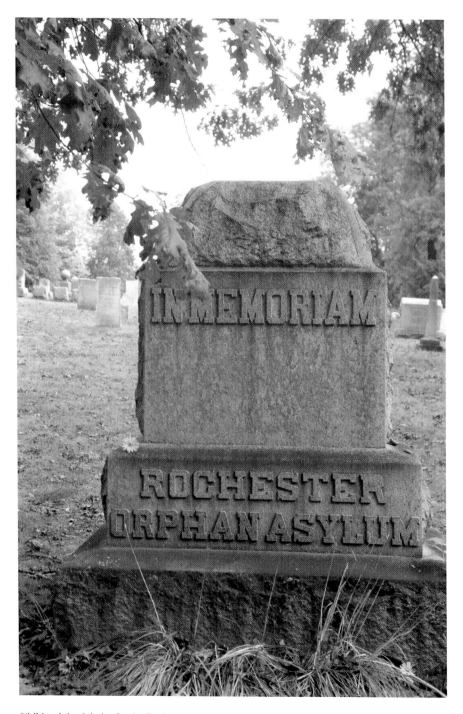

Children's burial plot for the Rochester Orphan Asylum at Mount Hope Cemetery. *Author photo.*

At dawn, the rising sun showed the true magnitude of the destruction: the asylum laid in complete ruins. Twenty-seven children and three caretakers died in the fire that night. Some of the children had died because they crawled under their beds, where they thought they would be safe, and were not discovered by the firemen until it was too late. In the days that followed, more would succumb to burns and smoke-damaged lungs. Most of the children who died in the fire were laid to rest at Mount Hope Cemetery in the Rochester Orphan Asylum burial plot. The asylum was rebuilt on Pinnacle Hill, and today it is the Hillside Children Center. The tragedy of the fire prompted the city to reevaluate its fire codes. An assistant fire marshal was hired, and stricter codes were written.

13
ROCHESTER RIPPER

Between August 31 and November 9, 1888, the Whitechapel neighborhood in the East End of London was rocked by the brutal killings of five women. It is perhaps still one of the most infamous unsolved serial killings of all time. Each woman's throat was slashed, and she was disemboweled. At least three of the women had a female organ removed with surgical skill and taken by the killer as a gruesome souvenir. The final murder victim, Mary Jane Kelly, was so brutally attacked that when her body was discovered in her room, it was almost impossible to identify the remains as human. Without the forensic technology that is readily available today, the detectives had little to go on. They were able to determine that the killer had a deep resentment toward women due to the vicious nature of the killings, and he (or she) had a medical or surgical background. Then, there were the letters. During the killing spree, the murderer sent letters to Scotland Yard boasting about the "good job" he did with each woman, almost taunting them. The letters were signed "Jack," which is how he earned the nickname Jack the Ripper. Until 1891, there were many copycat killings, but only the first (original) five can be linked together with certainty as the work of the same hand. Among the possible Jack the Ripper suspects, at least two were Americans. One was H.H. Holmes, America's first serial killer, and the other was a man from Rochester, New York.

Francis Tumblety was an Irish immigrant who came to America in 1836 with his parents and ten siblings. The family settled in Rochester.

Left: Newspaper article covering the murders in the Whitechapel area of the east end of London, 1888. The murders were never solved. *Afflictor.com*.

Right: Francis Tumblety, an American suspected in the Whitechapel murders. *Neil R. Storey*.

At a young age, Francis had a reputation as a troublemaker with local law enforcement. At the age of seventeen, he sold pornographic books up and down the Erie Canal, from Rochester to Buffalo. Tumblety would later get more respectable work as a janitor at Lispenard Hospital at 19 Exchange Street. According to an 1861 advertisement in the *Lyons Wayne Democratic Press*, it was an "old established hospital for the treatment of private diseases on the French System," or "gynecological operations and 'cures' for sexual temptation." Perhaps this is where Tumblety's perversion started; each job he was documented as having thus far in his life was connected to women in a sexual context. But other than that, how do we know that he had an aversion to women? It was no secret that Tumblety hated them. He had a vicious disdain for prostitutes, especially after his failed marriage to one. While living in Washington, D.C., in 1881 or 1882, it was discovered that he had an extensive and disturbing collection of uteruses and other female organs preserved in jars. He moved from place to place, never staying put for more than several months at a time. He probably acquired the specimens in Detroit, Michigan, or Canada, where he set up shop as a "great physician." It is important to note that there is no record of Francis Tumblety having ever attended medical school. He

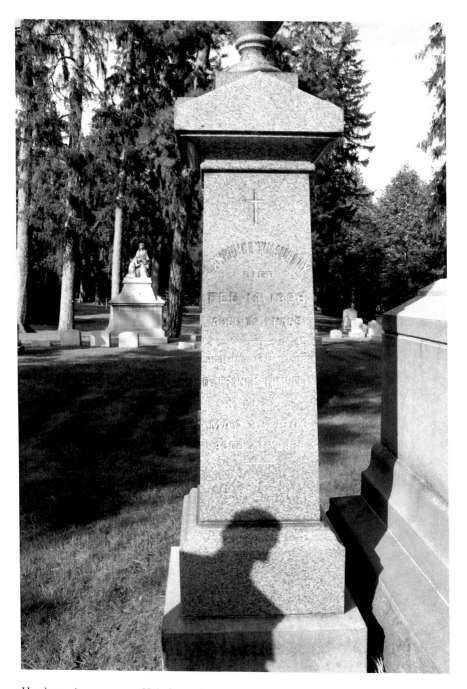

Headstone/monument at Holy Sepulchre Cemetery marking the resting place of Tumblety. Note the stone is engraved Dr. Francis Tumblety; however, he never attended a medical school. *Author photo.*

was an "Indian herb doctor" (snake oil salesman) and a practitioner of quack medicine.

In 1888, Tumblety was on a European tour, one of many trips that he made to Europe. On this particular trip, he visited Ireland, Scotland and England. During the Ripper killing spree, Francis lived in a Whitechapel boardinghouse. Police paid close attention to his movements; they soon decided that the stranger was a likely suspect for the murders. Tumblety was arrested for performing a "homosexual act." Charged with gross indecency, which was a serious offense, he was held in police custody awaiting bail. Scotland Yard finally got the opportunity to question him. Authorities held fast to the theory that he could be Jack the Ripper; however, the detectives lacked the evidence to hold him. He was released on bail for the indecency charge and was to stay in London to wait for his trial date to be set. Tumblety knew that his days of freedom were numbered, so he fled England the first chance that he got. Under the assumed name of Frank Townsend, Tumblety caught a ship to France and then set sail to New York.

His transgressions were well known in the United States; therefore, the police department in New York City had Tumblety under constant surveillance, waiting for him to slip up. However, even knowing what he was capable of, when the inspectors from London arrived in New York to take Tumblety back to England to face more Ripper case questioning, extradition was blocked due to lack of evidence. The men from Scotland Yard returned home empty-handed. Francis Tumblety got off scot-free if he was, indeed, Jack the Ripper, but the rumors and suspicion followed him for the rest of his life. He died on March 28, 1903, in St. Louis. His body was returned to Rochester, and he was laid to rest in the family plot at Holy Sepulchre Cemetery.

14
ROD SERLING

There is nothing in the dark that isn't there when the lights are on.
—Rod Serling

One of the fathers of science fiction television was a Finger Lakes native. Rod Serling, writer and narrator of the classic 1960s television series *The Twilight Zone*, was born in Syracuse, New York, on Christmas Day 1924. When he was only a year old, Serling's parents moved the family to Binghamton, where he spent his childhood.

Rod lived an ordinary childhood and was interested in doing all the things that boys his age did. He had a particular love for pulp magazines and movies popular at the time. In elementary school, he was the class clown, written off by his teachers as a lost cause. It was not until high school that his talent for public speaking and writing was finally acknowledged. Serling began writing for his school newspaper, which, according to a fellow journalist, earned him the reputation of being a social activist. Perhaps his school years were the inspiration for Rod's later writings.

The bombing of Pearl Harbor motivated Rod and his friends to enlist in the military right after graduation. He was a paratrooper and later a demolition specialist in the 511th Parachute Infantry regiment in the 11th Airborne Division. From 1943 to 1946, he saw action in the Pacific theater, fighting against the Japanese. The Battle of Leyte, in the Philippines, killed many of the men in his unit, and Rod himself was injured by shrapnel from a bomb explosion. The injuries he received in the battle earned him the Purple

Hidden History of the Finger Lakes

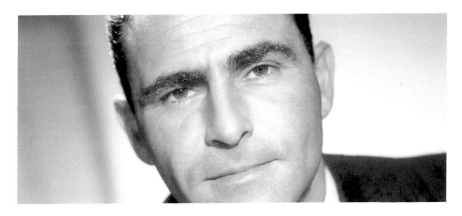

Classic Serling publicity head shot. *Syracuse New Times*.

Heart. After the war ended, Serling returned home, like most soldiers, with severe shell shock, otherwise known as post-traumatic stress disorder. He was kept awake most nights by nightmares about Japanese soldiers coming for him. These nightly episodes followed him for the rest of his life.

When Rod was physically and mentally able, he enrolled in Antioch College in Ohio. In 1950, he graduated with a bachelor of arts degree with a major in literature. While at Antioch, he met Carol, the woman he would marry. Going back to his high school roots, Serling wanted to write investigative dramas about touchy real-life issues, such as unions, lynching and racism. He was constantly being censored by networks touting conservative values. Tired of hitting the wall, Rod turned to writing science fiction. He was able to hide his socially conscious issues within this genre, getting past the conservative censors. While working at WKRC-TV in Cincinnati, he created a local television show called *The Storm*, which was the precursor to *The Twilight Zone*. Many *Storm* scripts were later reworked for *The Twilight Zone* when it launched in 1959. Serling wrote 92 of the show's 156 episodes, for which he earned three Emmy awards. After *The Twilight Zone* went off the air in 1964, he continued writing. Serling wrote several screenplays, including one for the 1968 *Planet of the Apes* film, as well as eleven books.

Rod, Carol and their two children moved to Interlaken, New York, on Cayuga Lake. He lectured and taught writing and literature at Ithaca College. In June 1975, Serling suffered a heart attack. He stayed a few days at a local hospital and then was released. Two weeks later, he suffered another heart attack and was sent to Rochester for open-heart surgery at Strong Memorial Hospital. During the ten-hour surgery, while on the operating table, he had

Rod Serling in his World War II army uniform. He was awarded several medals and commendations, including the Purple Heart. *Syracuse New Times.*

his third heart attack in less than two weeks. Two days later, on June 28, 1975, he died at the age of fifty.

Rodman E. Serling was laid to rest at Lake View Cemetery in Interlaken. His headstone pays tribute to his military service. Fellow science fiction writer Gene Roddenberry paid homage to the writer/activist Rod Serling. "No one could know Serling or view or read his work without recognizing his deep affection for humanity…and his determination to enlarge our horizons by giving us a better understanding of ourselves."

15
ROSE LUMMIS

There has always been somewhat of a romance with being on the water, from the beach near the ocean to lake cottages on a crisp autumn morning or cruising the mighty rivers and canals. Mark Twain conjured images of giant paddlewheel boats on the Mississippi River in his book *Life on the Mississippi*. Other tales that romanticized the rivers told about beautiful riverboats like the *Mississippi Queen* and the *Delta Queen*. They entranced the reader with adventures of the bigger-than-life characters that graced their decks. There were work boats pushing barges from port to port and pleasure boats that showed visitors the wonders of the river and the land along it. One modern icon of the Finger Lakes started out cruising the waters of the Mississippi River Basin.

Built at a Jeffersonville, Indiana shipyard in 1953, the *Miss Green River* was a fifty-five-foot, twin diesel tour boat. Some sources state that its first assignment was on the Tennessee River in Chattanooga. That may be true, but in a year or two, it was running tours along the Green River through Mammoth National Park in Kentucky. For at least twenty years, the *Miss Green River* maintained a daily routine of taking passengers on twelve-mile sightseeing and wildlife-watching expeditions. According to an advertisement from 1965, a day trip cost $1.15, and the sunset/twilight cruise was $1.25. When the *Miss Green River* was relocated to Vicksburg, Mississippi, it was replaced by the newer and much larger *Miss Green River II*. It was overhauled while at the port in Vicksburg, a paddlewheel was added to the hull, and the *Miss Green River* was transformed into the *Sea Witch*. Little is known about its

stay on the Mississippi River, other than it was short. A change of scenery was in the *Witch*'s future, from river life to the vast openness of lake living. The Arney family from Sodus Point, New York, bought the *Sea Witch* and brought the riverboat almost 1,300 miles north to travel along the southern shore of Lake Ontario in 1986. The paddlewheel was removed, and the *Sea Witch* underwent yet another name change. The old boat became the *Rose Lummis*, named after Madame Rose Lummis. Madame Rose was a Catholic missionary from Sodus known as "the woman who did the work of eleven men," but more about her later. The *Rose Lummis* served the Arneys well for over a decade. In 1998, Captain John Cooper bought the boat and began extensive renovations, which included the addition of an observation deck over the passenger cabin. The *Rose Lummis* was reactivated for service and started a new chapter of life. Captain Cooper moved the boat to Spencerport, offering cruises on the historic Erie Canal, occasionally docking at the Adams Basin Inn. The *Rose Lummis* served out its time in Western New York based out of Geneva. It cruised up and down Seneca Lake, entertaining passengers with tales of Indian lore, as well as the history and legends of the lake. This old girl, after sixty-four years of service, is now running along the Fox River in DePere, Wisconsin, under the name *River*

The *Rose Lummis* at its new home in Green Bay, Wisconsin, before becoming *River Tyme*. *WLUK Fox 11.*

An 1874 Beers map of Huron, New York, with businesses and landowners listed. Lummisville is on the map, located in District No. 9. *Wayne.nygenweb.net.*

Tyme. Now that you known the history of the boat *Rose Lummis*, let me tell you about our missionary, Madame Rose Lummis.

The Lummises were a wealthy family from Philadelphia, Pennsylvania. As a young man, Rose's grandfather Dr. William Nixon Lummis contracted yellow fever when the epidemic hit Philadelphia in 1793. Although he was

one of the lucky few who survived, the after effects of the illness left him in extremely poor health. The conditions of city living were unhealthy, unsanitary and crowded. In order to improve his health, he decided to move out of the city with his wife. They settled three hundred miles north along Lake Ontario in Troupville, New York, or present-day Sodus Point. The fresh, clean lake air must have done the trick and rejuvenated his health because Lummis was an active member of the local militia. During the Battle of Sodus Point in 1813, the volunteers defended the port against the British forces in the War of 1812. Soon after the war was over, William Lummis bought more than one thousand acres of land on the eastern shore of Sodus Bay and named it Lummisville. Dr. Lummis even ran the post office until he died in 1833. Lummisville is now just a point on an antique map, part of present-day Wolcott.

That is how the Lummis family came to New York. Fast forward to Madame Rose. She was born to Benjamin and Georgiana Lummis on September 13, 1843. It is important to note that her parents were Protestant. However, Benjamin and Georgiana held strong to the belief that their children could and should explore other religions and make the decision regarding their faith for themselves. This helps us understand the depth of her faith, knowing that Rose identified with it and chose it instead of following a family tradition. Rose's cousins in New York were raised Catholic by their mother, and Rose took an interest in learning more about their faith. After reading the book *Butler's Catechism*, a gift from her uncle, she decided on her faith. On February 20, 1865, at the Convent of Mercy in New Haven, Connecticut, Rose became a member of the Catholic Church.

Her urging to serve her fellow man ran deep, and Rose returned to Sodus to work with the Rochester Diocese to spread God's word and that of the church. Lummis Hall, the town's meeting place, served as a mission outpost where the town's growing number of Catholics could celebrate mass. Rose's mother, Georgiana, passed away in 1868. The shock of her mother's death was too much for Rose to handle, and she suffered a physical breakdown. From that point on, she was plagued with health issues and spinal problems for the rest of her life.

In 1876, the Catholic Church sent Rose to Simcoe, Ontario, Canada, two hundred miles west of Sodus, near the northern shore of Lake Erie, to work with the mission of St. Anthony Parish. Although Simcoe was the seat for Norfolk County, it was still a struggling, working-class mill town. Madame Rose was in her glory helping the poor. She worked to make sure that the children of the town were educated. She also taught catechism classes. The

children just adored Rose. She had a saying: "Win the children, and you have the parents." Soon, she was teaching the parents to read and how to live in the Catholic faith.

Tragedy struck the Lummis family again in 1882 when her father, Benjamin, died. Madame Rose returned to the family home in 1885; at that time, she and her sister Georgette deeded Lummis Hall to the Rochester Diocese. One year later, the hall was blessed as St. Rose of Lima Catholic Church, which still celebrates mass today.

At some point in her life, Rose joined the Society of the Sacred Heart in Halifax, Nova Scotia, becoming a nun. She traveled between Simcoe, which had become her second home, and Sodus. For a time, she practiced her duties as a nun in the fullest capacity. However, when her health declined further, she had to ask the church for permission to perform only the duties that her failing body would allow. Rose's health took a drastic turn for the worse in the fall of 1891. Her doctor told her that if she did not move to a milder climate with clean mountain air she would certainly die soon. Rose knew that she could no longer fight her body. Rose Lummis and a companion boarded a train that would ultimately take her to North Carolina. Before she left Simcoe, she used part of her considerable inheritance to bring a resident priest to the church, open a school and purchase three beautiful French statues for the church.

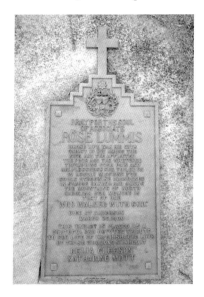

The plaque on the grave of Madame Rose Lummis at Silver Brook Cemetery in Anderson, South Carolina. *Brenda Pierce*.

The mountain air seemed to improve her health, and after the move, Rose continued serving those in need. In fact, she built another school, this one in Tryon, North Carolina, ninety miles west of Charlotte. She was always searching for those who needed help or a hand up. She moved on to Anderson, South Carolina, to establish a juvenile reform school. While in Anderson, Rose came down with a severe case of pneumonia that sent her to her bed. Within a few days, Rose Lummis died in her room at the Chiquola Hotel on March 26, 1900, at the age of fifty-seven. Her body was laid to rest at the Old Silver Brook Cemetery. Rose's grave has a plaque celebrating her saintly life:

Prayer for the Soul Associate Rose Lummis. Whose life was hid with Christ God among the sick and the afflicted the poor and the wretched triumphing over pain and helplessness she toiled on in lonely mission in Simcoe Canada and among the mountains of North Carolina. Her memory is that of one "Who Walked With God" Died at Anderson March 26, 1900

16
SCYTHE TREE

There are few monuments that immortalize the exact moment when one man decides to sacrifice his freedom and life for the good of others. One such monument sits in front of a farmhouse on Routes 5 and 20 in Waterloo. In 1861, President Lincoln called the men of the northern states to arms against a disobedient South. A young man named James Wyman Johnson put his scythe in the crook of the Balm of Gilead tree in the family's front yard and told his parents, "Leave the scythe in the tree until I return." And with that, James walked off to join the Union army. The last his parents saw of their son was his figure fading off in the distance.

Johnson enlisted in Geneva in the Eighty-Fifth New York Infantry. Most of the battles that he saw were in Virginia and North Carolina, including New Market, Yorktown and Blount Creek. James was wounded during a skirmish at Plymouth, North Carolina, on April 20, 1864, and was taken prisoner. Johnson's wounds were so severe that he was transported to a Confederate hospital in Raleigh, where within a month, he succumbed to his injuries on May 22. Johnson was laid to rest in an unmarked grave. His parents did not want to believe that their son had died, and they continued to look down the road, hoping to see him walking home. Both of them died without knowing where James's body lay, never getting to say goodbye. In 1916, his remains were found and identified in a Raleigh, North Carolina cemetery. Sergeant James Wyman Johnson was reburied with honors at Arlington National Cemetery.

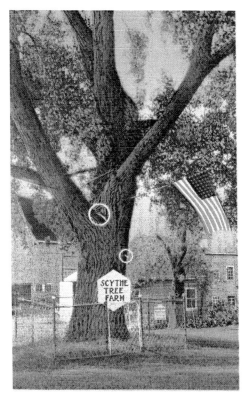
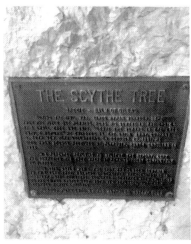

Above: Plaque at the Scythe Tree. *Chris Harmon.*

Left: A 1930s postcard of the Scythe Tree on Routes 5 and 20 in Waterloo. *Roadside America.*

It has been said that history often repeats itself. Fifty-six years later, as the United States was pulled into World War I, Raymond and Lynn Schaffer heeded President Wilson's call. Before leaving home, the brothers hung their scythes in the same Balm of Gilead tree as Johnson had hung his. Raymond enlisted in the Thirty-Third Engineers while Lynn sailed with the U.S. Navy. Unlike Johnson, both brothers returned home to their family. The brothers took the handles off their scythes but left the blades where they were as a testament to Johnson and their sacrifices.

The tree continued to grow and is now almost one hundred feet tall, with the blades of the scythes barely visible. It remains a memorial to the three who served and the one who never returned. In 1990, the Balm of Gilead was named one of only eleven trees with "extraordinary historical significance."

17
BROCKPORT SOLDIER TOWER

The laurel wreath is ready now
To place upon his loyal brow.
And we'll all feel gay when Johnny Comes Marching Home.
—*"When Johnny Comes Marching Home," Louis Lambert (1866)*

The Victorians knew how to honor their dead and veterans in spectacular fashion; everything that they did seemed elaborate and over the top. When I think of funerary and military memorials during this time, a classic movie scene comes to mind. It is a scene in *Gone with the Wind* when Rhett Butler is asked to make a donation to the "Association for the Beautification of the Graves of the Glorious Dead." The South did not hold the patent for honoring their fallen soldiers. Communities everywhere wanted to memorialize those who had served, just not always in such an elaborate and ostentatious way.

In 1882, the Brockport Rural Cemetery Association was formed with Horatio Beach, publisher and American diplomat, at the helm. The cemetery committee, with help from the local GAR (Grand Army of the Republic), as well as the Cady Post, secured a beautiful twenty-three-acre lot overlooking the village. Beach's vision for the Brockport Rural Cemetery was for it to become a miniature version of Arlington National Cemetery. Civil War veterans in Sweden and Clarkson were leaving the land of the living in great numbers. Beach and the committee wanted the cemetery to be a testament to them for their service to their country.

Imagine the civic pride that was felt by every craftsman who contributed to its construction. The Medina Sandstone came from a quarry in Hulberton ten miles away and was transported on the Erie Canal by barge to Brockport. The ironwork was forged at the Morgan Foundry in the village. Local masons laid the stone blocks. Every piece followed the plans created by Clarence Birdsall, the man responsible for several monuments on the Gettysburg Battlefield. The creation of the cemetery and its monument was an arduous undertaking that took nine years to complete.

On September 1, 1894, the cemetery and monument were dedicated. It was the biggest event that the town had seen before and for decades after. Thousands streamed into Brockport to join in the celebration. Train companies offered special rates for the excursion. Those who did not come by rail came on foot or by wagon. A parade kicked off the day, beginning at the Public Building and weaving its way to the cemetery. Once there, a band played while the committee and other dignitaries took the grandstand. Horatio Beach gave a rousing oration, proclaiming that the monument and cemetery was "for the free interment of all loyal soldiers who have died or may die in Brockport or town in the vicinity." He also said, according to the *Brockport Republic* on September 6, 1894, "The Brockport Soldier's Monument Association was born August 22, 1892. Those present at its birth were full of faith and endowed with indomitable spirit of perseverance.… [T]he outcome is this colossal column-grand, stately ornamental—an honor alike to the brave soldiers whose valiant deeds it commemorates."

The tower was the centerpiece of the cemetery. It was fifty-two-feet tall, made in the Gothic Revival style with an iron staircase running up the center to a beautiful observation deck. As Horatio Beach hoped, the cemetery had become a destination point. It even had a listing in the New York Central Railroad's 1895 travel guide (page 155) titled *Health and Pleasure of America's Greatest Railroad*. At the height of its popularity, the cemetery held the graves of at least 20 veterans. At the time, the town of Sweden alone had 293 Civil War veterans.

Tragedy struck the Brockport Rural Cemetery three times. The first was in 1898, when Horatio Beach passed away. He was the cornerstone of the whole project, and his enthusiasm was what gave it life. After Beach's death, the cemetery began to show signs of neglect. Lightning struck the observation platform at the turn of the twentieth century, rendering the deck unusable, and it was never repaired. The ironwork rusted, and the mortar on the battlements crumbled. In 1917, a grass fire quickly spread across the cemetery, destroying the chapel, caretaker's cottage and the vault. The

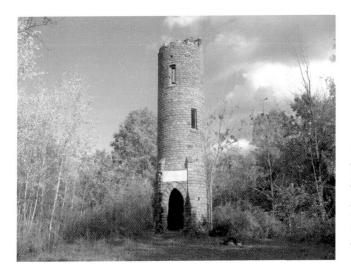

Present condition of the Soldier's Memorial Tower. The few graves around it are unmarked, and the tower is in danger of collapsing. *Waymarking.*

neglect became shameful, and the families of the veterans buried there began to have their loved ones reinterred elsewhere. Most of the remains were moved to Lakeside Cemetery just north of the village. The condition of the cemetery had become so bad that it was not recognizable as a burial ground. All of Beach's hard work was falling to pieces. To add insult to injury, the June 27, 1940 issue of the *Brockport Republic Democrat* published an interesting story that read in part:

> *At the beginning of the 1900s the land around and including the tower and cemetery was sold to Nort Johnson, who used it for farm land. Mr. Johnson sold it to another villager, who also planted some crops but when authorities discovered that he was ploughing over graves, he was threatened with arrest. It worried him so that he jumped into the canal near the Brockport Fruit Association and was drowned.*

The property was abandoned and fell into a severe state of disrepair. The sandstone blocks on the top of the tower started to crumble, and most of the top half has fallen down. The Brockport Rural Cemetery is the final resting place for eight local veterans. In 1984, the cemetery and tower were added to the National Register of Historic Places. Fundraising efforts are taking place to restore the tower as the proper monument and military memorial that it was always meant to be.

18
TROUTBURG

Troutburg is a ghost resort. The Storey House once familiar to many Rochestarians as a popular dining place, is only a heap of rubble. It burned down two years ago. The dance hall under the willows is being dismantled. Dingy streamers, once gay, hang down from the rafters. The high water has eaten away at the piers, grass covers the cement walks along the shore.
—The Ridge: Ontario's Blossom Country, Arch Merrill (1944)

Near the end of the nineteenth century, there were no fewer than twenty summer resorts along the shore from one end of Monroe County to the other. Some have familiar names, even though they no longer attract the crowds, such as Summerville, Sea Breeze, Charlotte (Ontario Beach Park), Glen Haven, Newport and Crescent Beach. These resorts are where the "summer people" flocked.

One of the first summer resorts in the area, and one of the least known or remembered, began as a small fishing station at the very western edge of Monroe County in 1820. In fact, Troutburg straddles the boundary of Monroe and Orleans Counties at the end of present-day Route 272. The name Troutburg was chosen to represent the large number of lake trout that were caught there. Hiram Redmond ran the fishing station and decided to set up a hotel to offer entertainment for the fishermen. It remained just a place that men went to fish for decades because it was out in the wilderness, surrounded by forests and farmland, not unlike hunting camps today.

Troutburg did not begin to earn resort status until the years just prior to the Civil War. Asa Lee bought a beautiful piece of land on the lakeshore west of the county line in either the late 1840s or 1850s. The land was left wild until 1860, when he gave it to his daughter-in-law Sarah. She began construction on what would become a first-class resort, making Troutburg a destination for people from miles and miles around. Sarah Lee's property had a beautiful house, picnic grounds and a barn large enough to keep as many as sixty horses at one time. There were two sailboats and several rowboats docked at the pier for the guests to use. When the summer heat bore down on the city of Rochester and its suburbs, the wealthy traveled out to the countryside to escape the heat, enjoy the refreshing lake breezes and swim in the cool waters. At first, overnight accommodations were not available at the Lee House; people would pitch tents in the grove. In the mid-1870s, guests could rent rooms in the house for a reasonable fare.

Soon, there were three hotels at Troutburg, drawing thousands of visitors throughout the summer. The Ontario House was built by Silas Holbrook in the 1890s on the spot where the Lee House had once stood. There are no formal reports as to the demise of the Lee House, but it is inferred that is was destroyed by fire in many memoirs of those living at the time. When Holbrook, an employee of the college at Brockport and a Civil War veteran, built the Ontario House, he only allowed for construction of the hotel to take six weeks. It was an incredible deadline for the nineteenth century. At its completion, the property boasted not only a beautiful hotel but also a grand dance hall and picnic pavilion, as well as the extant large barn.

William Bush built his hotel across the street from the Ontario House in Monroe County. Bush's property had a restaurant, a bowling alley with a bar

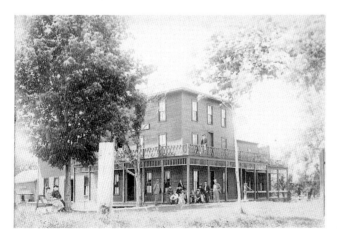

A late eighteenth-century photograph of the Ontario House. The resort was destroyed by fire in 1943. *Orleans County Historical Society.*

Postcard image of the pier at the Ontario House. The concrete pilings remain under the waters. *Orleans County Historical Association.*

and picnic grounds. In *History of Brockport with Vicinity Happenings*, one of the contributors remembered: "There was a hand operated merry-go-round on the front lawn of the Bush resort. A man would be sent out to turn the crank if enough riders were present to make it worthwhile."

The Cady House was the third hotel at Troutburg and by far the largest. The Cady House was part of Cady Grove, a large piece of land between William Bush's hotel and the lake. Cady Grove had a dance hall and picnic grounds that were popular with Sunday school groups, churches and businesses. It would not be uncommon for several different groups to use the grove at the same time. The Cady House burned down, and it was many years before it was rebuilt. In the meantime, the Cady family built cottages, which they rented out.

Troutburg's harbor had several docks to accommodate ships delivering lumber and other goods across the lake from Canada, as well as an excursion steamer that took tourists over to Coeburg, Ontario. The Ontario Gun Club met south of Cady Grove for skeet-shooting competitions. In the late nineteenth century, boat racing was popular, especially at the Brockport Yacht Club. Throughout the sailing season, several cup races were held along the south shore of the lake. The Gordon Cup race ran from the yacht club west to Troutburg and back. The resort was a flurry of activity, never a dull moment. The excitement did not just come from the lake resort hotels and the grounds— sometimes others brought the excitement with them.

Until 1920 and the passing of the Walker Law, prizefighting was illegal in New York State. This did not stop the fights from happening; the participants just had to get creative with the venues. During the night of Sunday, August 23, 1885, the steamer *Angler* left the Port of Rochester; early the next morning, the *Charlotte* pulled away from the dock as well. Both boats were headed to the same place, west to Oak Orchard, to witness a prizefight between Rochester's own Patrick Slattery and William Baker from Buffalo.

Spectators paid $5 each, a hefty price in 1885, and boarded the *Angler* and *Charlotte* to see the fight. However, when they reached Oak Orchard, there were no boxers or even a ring to be found. Orleans County sheriff Howard had already arrested both men, and they were being held at the jail in Albion. By 10:30 a.m. on August 24, 1885, the judge had arraigned them, charged them with conspiracy to engage in a prize fight and released them on a $400 ($10,000 today) bond. Baker and Slattery quickly got out of town, with about two hundred men in tow who had paid to see the fight. They all boarded a steamer and headed for Troutburg. As soon as the boat docked at Troutburg, a ring was set up in Cady Grove, and bets were taken. At 4:48 that afternoon, the two fighters stepped into the ring, and the Marquis of Queensbury rules were read by the referee. With a shake of their hands, the match began. The men pummeled each other for six rounds. According to an article in the *Rochester Democrat and Chronicle*, "Their faces showed the effects of the brutal punishment." Baker put Slattery on the ropes and fouled; in a controversial decision, Slattery was declared the winner. As fast as the ring was set up, it was taken down. And before the police could show up with paddy wagons and haul everyone off to jail, the crowd scattered. The fighters and their entourages hopped the Rome-Watertown train passing through Morton and hightailed it back to Rochester.

Prizefighting was not the only illegal activity that took place at Troutburg. During Prohibition, rumrunners used the cloak of night to bring alcohol in from Canada. The *Rochester Democrat and Chronicle* published an article on July 7, 1924, about some men caught doing just that. Six men from Rochester were arrested and being held at the Genesee County jail in Batavia on the charge of transporting intoxicating liquor. Two thousand cases of Canadian ale and two trucks were confiscated right after the alcohol was unloaded from a boat that landed at Troutburg. Michael Cappizzi's farm near Morton was the hiding place the bootleggers used. As for the boat and its captain, neither were caught. They had slipped into the darkness off shore and were long gone before the state police arrived.

After the Great Depression hit the country, the hotels in Troutburg slowly began to close their doors. William Bush sold his hotel to Edward Burns, who turned it into his private summer home. Burns's friend Colonel Grief, a man who made his fortune in the sugar industry, built a large summer estate on the west side of County Line Road. When Grief died, the Salvation Army bought the estate, and it became a summer camp for underprivileged children. The Ontario House burned down in 1943. Erosion over the last century ate up the shoreline, and the foundation of the Ontario House is

now underwater about thirty feet from the shore. The Cady House is the only one of the hotels still standing. It closed down in 1941, and a large portion of Cady Grove was sold to the Assembly of God Church for retreats and other programs. Now, they don't even use the property. The windows of the Cady House are broken and boarded up. As a result of decades of winds and storms, all of the paint is gone from its weathered boards.

A grandson of William Bush said it best in his 1970s memoir: "To recall my childhood and youth in this prosperous little farming community and pleasant lakeside resort is an exquisite pleasure.…Now, the bulwark of America, the family farm, has gone down the drain, and little hamlets of Troutburg and Morton are but pitiful derelicts of a wonderful past."

19
TWO FOXES AND THE DEVIL

The Fox family moved into the house on Hydesville Road on December 11, 1847. Prior to the family renting the house, there were rumors about numerous unexplained events that had driven out the families before them. It did not take the Foxes long to find out that the rumors were true. Each night, as the family was getting ready for bed, a mysterious rapping could be heard coming from inside the walls all around them and on the furniture, particularly the footboard of the bed. The noises continued every night for months. The family was sure that they were being made by spirits in the house.

Kate and Maggie, the youngest of the Fox daughters, decided to try to make contact with whatever was disturbing their sleep. The girls started by asking a series of simple yes or no questions, instructing the entity to respond by rapping out its answers. Soon, Kate and Maggie began receiving answers. The entity identified itself as "Mr. Split Foot," which was another name for the Devil. The girls began to have regular conversations with Mr. Split Foot. The events at the Fox home started to draw the attention of the neighbors, with a little help from the girls planting a seed of curiosity in passing. It began as small groups but quickly turned in to crowds; people came nightly to watch the sisters converse with the Devil.

After a while, Kate and Maggie said that they were now communicating with Charles Rosna. Rosna was a traveling salesman who went door to door peddling his wares. The thirty-one-year-old peddler disappeared in 1843, five years before he made contact with the girls in March 1848. His story

that he told Kate and Maggie was that he came to the house trying to sell his goods and was murdered on the property. Rosna told them that his body was buried in the basement to cover up the crime.

The house was originally built around 1815 by a Dr. Hyde, for whom Hydesville was named. Hyde built it for the purpose of renting it out, and between 1815 and 1847, many families lived there. From 1842 to 1843, the Bells rented the house. It was during that time that Charles Rosna came to the house and subsequently disappeared. Along with the Bell family, their housekeeper Lucretia Pulver also lived there. According to an interview with Lucretia, she was there the day that Rosna knocked on the door. At the time of his arrival, Mrs. Bell was not at home; however, she did come home while he was still showing Lucretia what he had for sale. Whether or not Mrs. Bell had ever done this before, she saw an opportunity for something sinister when she met Rosna. For whatever reason, in order to carry out her plan, Lucretia needed to be out of the picture. Mrs. Bell was fond of Lucretia, so no harm came to her, but Bell called her into another room and relieved her of her duties. Lucretia was upset and confused, but she packed up her belongings and went back to her parents' home. That was the last time she saw Charles Rosna. A few days later, Mrs. Bell called on her and offered her the housekeeping job again. On the way back to the Bell farm, Mrs. Bell lavished Lucretia with gifts and told her all about the things she had bought from Rosna before he moved on. At the time, Lucretia had no reason to question her story. That night, Lucretia was kept awake all night by rapping in the wall and at the foot of her bed. Bell tried to explain away the rapping as rats in the wall. No amount of rat poison made the rapping stop, and by the end of the year, the Bell family was gone.

The next family to rent the Hyde cottage was the Weekmans. For three long years, the Weekmans endured the strange noises and other phenomena, figures that mysteriously materialized and icy cold touches. How the family braved it for so long is unknown, but suddenly, they packed their belongings and left in 1846. The house remained empty until the Foxes moved in. Back to the rapping of March 1848. The story of Kate and Maggie's otherworldly conversations reached the desks of newspapermen, and within a week, articles appeared in newspapers all over. An article was printed in the April 27, 1848 issue of the *Evening Post* in New York City:

> *The ghostal arrangements which have for some time astonished the good people of Hydesville, Wayne County, and the surrounding neighborhood, continues still to be the wonder of the day. It seems that the mysterious*

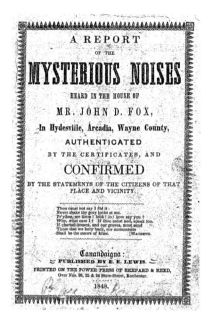 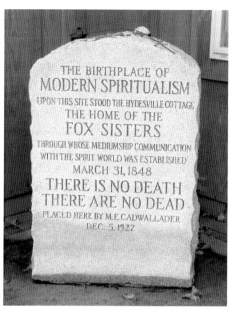

Left: An 1848 pamphlet about the occurrences at the Fox house.
Right: Monument at the site of the Fox house. *Author photo.*

rapping had been heard for a considerable length of time, at the great terror of the occupants of the house.... [T]he ghost was told that if he really was a spirit "to rap three times." The mysterious visitor complied, the raps freezing the blood in the veins of the listeners. Other questions were asked and answered in the same way, the spirit informing his audience that it was murdered, and the body underneath the ground.... The excitement now waxed high, and the crowds visited the haunted house.

Articles like the one in the *Evening Post* brought in more people; they descended on the farm by the hundreds. Between the crowds of spectators and the increasing frequency and intensity of the strange phenomena, the Fox girls' mother feared for their safety and sent them to live with their older sister Leah in Rochester. The younger Fox sisters continued to showcase their abilities to communicate with the afterlife in parlors across New York and eventually Europe. That little house at 1510 Hydesville Road was the birthplace of Spiritualism. A headline in the *Brooklyn Daily Eagle* on March 9, 1893, announced "Margaret Fox Kane, the Medium, Dies." Kate died a year earlier. Both were poor and broken at the time of their deaths.

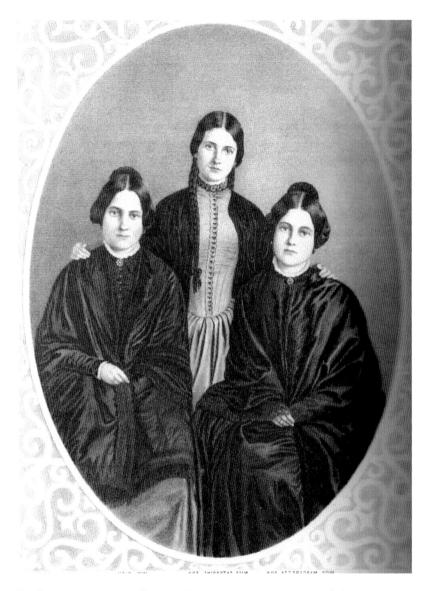

The Fox sisters: Margaret, Kate and Leah. *Newark-Arcadia Historical Society.*

In 1904, more than ten years after the death of the Fox sisters, some children were playing at the old Hyde cottage. By then, it had been empty for a half of a century since the Fox family left. No one dared live there; they all had heard the stories. The children found a partial skeleton between a wall and the basement foundation, most likely the remains of the missing

peddler Charles Rosna. In 1915, B.F. Bartlett bought the Hyde cottage and moved it to the Spiritualist community of Lily Dale in Chautaugua County. A fire on September 21, 1955, destroyed every last splinter of it. All that remains of the original home on Hydesville Road is the old stone foundation. A memorial park was built on the site of the farm; the foundation is enclosed in a protective building as sacred ground for the Spiritualist Church.

20
WILLARD

We die twice—once when we draw out last breath and again when the living no longer speak our name.
—Banksy

The care of the mentally ill was at one time the responsibility of the family and their community. In the nineteenth century, the names that were used to describe them were demeaning and cruel. Society would tolerate them but felt that they could not offer anything of value to society. Before the 1800s, mental illnesses were looked at as more of a curse and, in some cases, as an affliction cast upon that person by the Devil himself. Church leaders had supreme control of their congregations and would strike fear in the minds of the poor and uneducated by telling them that any deviation from God's (and the church's) laws could bring down this type of punishment on them and their family. For example, a woman had a child out of wedlock, and the child was born with a mental illness. It was believed that God punished the woman for her transgressions with an "idiot" child—there was no political correctness at that time. Families hid their lunatic relatives away from their neighbors as best they could so that they would not be judged. This was especially true in small communities and remote villages. In rural areas, the insane were targets of "witch hunts," automatically blamed for various crimes and unexplained events. Therefore, instead of getting the help that they desperately needed, they were often imprisoned and tortured. Advances in medicine toward

the end of the nineteenth century shed some light on the disorders and diseases of the brain. Courses of treatment were developed, but they were horrifically painful and sometimes responsible for the death of the patient. The scientists who made significant breakthroughs in psychology and psychotherapy did not come on the scene until the beginning of the twentieth century. Until these medical pioneers arrived, people advocated for humane treatment.

In 1824, the New York legislature passed a law that required every county across the state to open a poor or almshouse that would support those who could not take care of themselves and were a burden to society. Services at the county homes were not just limited to taking care of the poor and destitute citizens; by law, the door was open to the community's lunatics as well. While the mentally ill were figured into the equation when the law was written, the legislation had no idea about the true extent of the problem. To say that there was an increase in the number of mental illness cases would be incorrect. It would be more accurate to say that what it revealed would be the tip of the iceberg.

Sixteen years after the first poorhouse opened in the state, so many people suffering from mental illness turned to the county for help that the state was compelled to open a hospital dedicated to only those cases. In 1843, the New York State Asylum at Utica opened, followed by several private mental institutions. Although the Utica Asylum was equipped to handle the majority of the cases, there were limitations to the care that it provided. Only acute cases were admitted, and if patients were not "cured" within two years, they were remanded back to the custody of their county home as a lost cause. Those deemed incurable or "chronically" insane by their physician at home would not even be seen at the state asylum at all. Most families could not afford the small fortune to have them privately institutionalized; as a result, they remained in the care of the poorhouse. In the meantime, the state asylum quickly filled to capacity and became overcrowded. The protocols carefully set pertaining to the treatment of patients were soon disregarded. Patients were discharged before their two years were up regardless of the progress in their recovery in order to accommodate new patients in desperate need of help as well. The system began to break down. As a result of overcrowding and the increasing number of people seeking treatment, many were simply turned away.

The insane were once again forced to turn to their local poorhouses. The dilemma facing the poorhouses was that they were not equipped to

handle any type of mentally ill resident, especially those whose conditions were chronic and deemed incurable. The physicians at the poorhouses generally had their own private practice in addition to their duties at the county home. The doctors made regular rounds to see the residents or inmates, as they were often called, once a month unless there was an emergency. And even then, they had limited education in regards to mental disease. General, everyday care was routinely maintained by stewards and matrons, the equivalent of a hospital orderly of today. It was no stretch of the imagination that the treatment of the insane was less than stellar. In fact, they were often "chained and shackled to the floors and walls in windowless basements, outhouses and sheds."

Sylvester D. Willard, a physician from Albany, was appalled by the mental health system, and in the 1860s, he played an important role in reforming the treatment of the mentally ill. He came from a long line of humanitarians, religious leaders and doctors. Therefore, Dr. Willard took his duty to serve his fellow man seriously. His integrity and morals are summed up perfectly in this excerpt from his 1864 obituary. "He possessed a large executive ability and power to readily bringing other minds into harmony with his own.…His moral qualities were akin to his intellectual one. He had great simplicity and directness of character. With him the question 'What is right?' was all absorbing and he sought to settle it by light from above and within."

Dr. Willard oversaw the investigation into each poorhouse in New York State and was astounded by what he found. It was much worse than he could have ever anticipated. Cleanliness was not enforced; the mentally ill residents were covered in their own filth and feces. Many slept on loose straw spread directly on the hard floor. The straw was wet with urine and feces, not unlike the pens that housed livestock in a barn, and it appeared to have not been changed in days or even weeks. There was inadequate ventilation, which meant that they had little or no fresh air. Some of the residents were kept in dark, cramped cells or cages, often with no shoes or clothing, which became extremely unbearable in the winter months. He took his findings to the New York State legislature to campaign for change. Six days before his death, a law was passed that called for a new state asylum, which would be named after him. This was the answer to everyone's prayers, or so they thought.

Willard Asylum for the Insane started off small, a 250-bed facility in the old agricultural college building on the shore of Seneca Lake. It was the perfect location, with an open landscape of farmland and a central

Finger Lakes location. It would provide hope to those who had become hopeless. The very first patient at the asylum arrived at Ovid Landing by steamboat on October 12, 1869. Mary Rote, a twenty-eight-year-old Columbia County woman, had been an inmate at the poorhouse there for more than a decade. The exact nature of her illness has never been publicly revealed; however, the treatment that she received near her home and her physical appearance when she arrived at the dock have been. Mary spent ten years of her life chained to the wall of her room, reportedly with no bed or clothing. When she got off the boat, she was physically deformed; her atrophied muscles made it nearly impossible to walk. Mary Rote did not arrive alone. There were three men who also came across the lake, but she was given the honor of being registered as patient number one. The men arrived in no better condition than Mary. They were bound in irons and chains. One unfortunate soul was confined to a box no bigger than three and a half feet square, the box resembling a chicken crate.

At first, the main objective, and Dr. Willard's vision, was to transition the patients from the horrific treatment that they were used to at the county home to the compassionate care that they would receive at the asylum, as the definition of asylum is "a place of retreat and security, a sanctuary." Each new patient was bathed, clothed and fed, something that was foreign to many of them. No occupational skills were taught; however, the asylum was designed to be self-sufficient. Those who had tangible skills and talents were put to work. By some accounts, there were reports of slave labor—long hours and harsh working conditions. None of the accusations was ever substantiated. Those who were unable to work were given activities like puzzles and crafts to occupy their time.

There was a dark side behind the façade. A trip to Willard often came as a one-way ticket to a living hell, especially during its first seventy-five years. For most, the only way out was in a plain pine box. In fact, nearly half of the fifty-eight thousand patients treated at Willard died there. The cause of those deaths was not always attributed to their illnesses but rather inhumane and experimental treatments. Unfortunately, we will never know the truth, because the death records are either incomplete, missing or sealed by the state.

The stigma that the families believed to be attached to them for having a relative with a mental illness led to the abandonment of lunatics on the asylum's doorstep. Aside from being admitted for a bona fide mental illness, people were sent to the asylum for other reasons ranging from

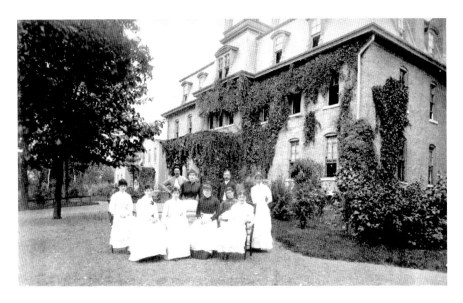

Victorian photograph of doctors and nurses. The building now stands in near ruins. *Inmates of Willard.*

the disturbing to the absurd: intemperance, masturbation, inbreeding, desertion by husband, novel reading, time of life, superstition, grief and laziness. Most of the time, the family was simply trying to avoid embarrassment for what were actually minor illnesses and behavioral problems. Because of this embarrassment, almost all of the patients who were dropped off would never see their families again. Even after death, patients remained alone, their bodies unclaimed. During the nineteenth century, the government saw this neglect as a way to further medical research. Willard and other state-run institutions were required by law to turn any unclaimed bodies over to a medical school to be used as research cadavers. After the law was discontinued, the bodies of the deceased were buried in the Willard Cemetery. And there they remained anonymous and forgotten, only to be known as an obscure number.

One man would make it his life's work to see that his fellow inmates were given the respect that they deserved in death that they had not received in life. Lawrence Mocha was born in 1878 in Austria to poor parents. When he could find work, he learned the trade of metalworking to earn a decent wage. That was until 1905, at the age of twenty-seven, when he suffered a severe head injury after being struck with a rock. The side effect of the

injury, perhaps brain damage, was alcoholism. The excessive drinking led to loud and exciting singing and whistling, which led to his first stay in an asylum in Dusseldorf, Germany. When he was released, he made his way to the United States in 1907.

Lawrence entered the port of New York City and soon found employment as a window washer at Bellevue Hospital. Desperate to fit in to his new surroundings, he took night classes to learn English. It would be his job at Bellevue that would land him in an asylum for a second and last time. Lawrence had a "spell" in 1916; he began singing loudly and energetically while praying and claimed to hear God speaking to him. The behavior quickly earned him a reservation in the psych ward, where he continued to insist that he had heard God and saw angels.

At the age of forty, he was transferred from Bellevue to Willard. Once there, he kept to himself for the first years of his stay. But soon, he wanted to work outside doing grounds maintenance, which transitioned to digging graves. He began digging perfect burial plots by hand for the deceased. Like many of the residents at Willard, he had no one to advocate for him, so he spoke up for himself.

On October 19, 1945, he wrote a letter to the superintendent at Willard asking for his release. The letter read:

> *Dr. Keill,*
> *I hereby Lawrence Mocha stop work. Yesterday afternoon, I ask you Dr to discharge me from Willard Institution. I am capable to do my living independently I want also to get money for my work here, I make over eight years more than five hundred graves myself another heavy work all year around. I ask Dr to prepare my trunk, which I brought here from Central Islip it is my own I bought it in Dusseldorf.*
> *I am respectfully yours.*

The answer to his letter was digging graves for twenty-three more years, unpaid. And in 1868, at the age of ninety, he died and was buried among the rest. Willard groundskeeper Gunter Minges said of Lawrence, "He dug until he died." During his fifty years at Willard Asylum, Lawrence Mocha dug more than 1,500 graves.

Although he worked tirelessly to give the deceased the dignity in burial they deserved and would not get from the hospital, he did not receive the same in return. His passing earned him a simple numbered stake. In 2015, a group working to give the deceased of Willard the recognition they

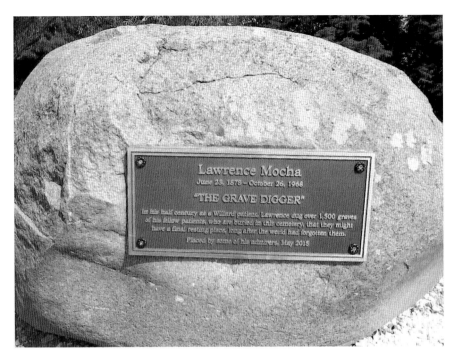

The memorial erected dedicated to the faithful and compassionate service that Lawrence Mocha gave to his fellow inmates at the Willard Asylum. *Sumpter Blue and Gray Review, October 9, 2017.*

deserved honored Lawrence with a plaque on a stone at his burial plot. The plaque reads:

> *Lawrence Mocha*
> *June 23, 1878–October 26, 1968*
> *"The Grave Digger"*
>
> *In his half century as a Willard patient, Lawrence dug over 1,500 graves for his fellow patients, who are buried in this cemetery, that they might have a final resting place, long after the world had forgotten them.*
>
> *Placed by some of his admirers, May 2015*

The Willard Cemetery is on a hill along the eastern shore of Seneca Lake overlooking Ovid Landing. The view is picturesque and serene, a contradiction of its purpose. The only indication that there is a cemetery

in the clearing comes from a sign on the road at the bottom of the hill that reads, "Willard Cemetery—This cemetery was used from 1870–2000. Here laid to rest are 5,776 departed Willard residents."

In the northwest corner, under the canopy of a hardwood tree, are the graves of thirty-eight Civil War veterans, marked and decorated with American flags. Each of the veterans served in the Grand Army of the Republic and were all patients at Willard. The southwest corner has a fenced-in area with a simple arch bearing the words "Old Jewish Cemetery." Placed in front of the arch is a large stone with "In Remembrance of the Jewish residents buried at Willard Psychiatric Center 1870–1992."

The rest of the meadow holds the remains of thousands of people who died over 130 years. Originally, each grave was marked with either a wooden stake or a metal disc with their number on it made in the foundry at the asylum. Over time, the wood rotted away, the discs sank in to the earth and grass grew to cover them. To a stranger, this was a beautiful, quiet meadow.

Not all of those who died at Willard are laid to rest there. Patients who passed on in the asylum's first few years were placed in an unmarked cemetery behind Grandview, the original building. They are also buried

The vast openness of the Willard Cemetery. *Author photo.*

in "patients row" in Ovid Union Cemetery and in unmarked graves in the Holy Cross Cemetery. In May 2016, Holy Cross Cemetery dedicated a granite memorial with the names of the 268 Willard patients buried there. Those who have not been given their due respect are set to be forgotten by society forever; once they left this earthly realm, it was as if they never existed. However, the lives of over 400 people were about to be rediscovered.

In 1995, New York State decided to shut down the Willard Psychiatric Center, due to both increasing operating costs and declining patient numbers. What few patients remained there at the time were transferred out to nursing homes and other facilities. As the last patients were discharged, the staff had the daunting task of cataloguing and inventorying the contents of each of the buildings. A couple of workers thought they had finished one building and were doing their final walk through when they found a door to the attic that they had never noticed before. When that door opened, they saw shelves of suitcases and boxes. Beverly Cartwright, who was one of the pair, felt an energy in the large room the moment she opened the door and thought, "It was like they were still tied to the few remaining treasures and did not find their way home."

Contained in the attic were 427 suitcases, neatly placed on the shelves in alphabetical order and separated by gender. Each was tagged with the owner's name and patient number; they belonged to people admitted between 1910 and 1960. They contained bits and pieces of their personal lives—things that were important to them—records, sewing notions, travel souvenirs, family photographs and letters, figurines, books and personal care items. There the suitcases sat until their owners got to leave the asylum; however, no one really ever left Willard. When patients passed away, their possessions were rarely claimed by family. The staff who had developed caring relationships with them could not bear to just throw them away. As time went on, the nurses and orderlies came and went, and the existence of the suitcases were forgotten until that day in 1995. Each suitcase and box had a story to tell. Two of those stories are that of Margaret and Dmytre.

Margaret was a tuberculosis nurse who suffered from the horrible disease herself. She was forcibly admitted to Willard on the simple charge that she annoyed people. She came to Willard in 1941 feeling "like a fly in a spider web," and she stayed trapped in that web for thirty-two years until her death. Margaret brought with her a staggering eighteen suitcases and boxes containing her entire life. After she died, her family—who brought her there—left her life behind them.

Dmytre and his wife came to the United States in 1949 from the Ukraine after being interred in Nazi work camps during World War II. When they arrived in America, they settled in Syracuse in a largely Ukrainian neighborhood. Sophia was pregnant, and soon after moving, she suffered a miscarriage and died. Dmytre lost his mind and became delusional. He began having fantasies about being married to President Truman's daughter, Margaret. In 1952, he took a trip to Washington, D.C., and knocked on the White House door asking to see his wife. He was quickly arrested by the Secret Service and placed in a mental institution. A year later, he was transferred to Willard. Dmytre was a model patient and a prolific artist; many of his paintings are in local galleries and museums. He was one of the few who left Willard; placed in the care of a county home, he died in 2000. His suitcase remained with the others.

Bibliography

Chapter 1

Allegany County Historical Society, alleganyhistory.org.
Andover News. August 2, 1951.
———. May 11, 1934.
———. September 1, 1922
Raisin' the Brick, Con-Vericht Films, 2012.
Ray's Place, Explore New England's Past, history.rays-place.com.

Chapter 2

Buffalo Morning Express. June 27, 1882.
Crooked Lake Review (Summer 2005).
Daily News (Batavia, NY). June 27, 1882.
Gilbert, David. "Dansville's 'Castle on the Hill.'" Dansville Public Library. dansvillelibrary.org/community/castle-on-the-hill.
Wayne County Times June 24, 1937.

Chapter 3

Anti-Masonic Enquirer. November 1829.
Buffalo Republican, October 1829.
Colonial Advocate, October 1829.
Democrat and Chronicle. April 4, 2017.
Merrill, Arch. *Rochester Scrapbook.* Rochester, NY: n.d.
Nickell, Joe. "The Story of Rattlesnake Pete." Investigative Briefs, April 15, 2013. centerforinquiry.net/blogs/entry/the_story_of_rattlesnake_pete.
Rivers, Tom. "154 Years Ago Today, Tragedy Struck." September 28, 2013. orleanshub.com/154-years-ago-today-tragedy-struck.
Rochester History 49 (July 1987).
Rochester Republican.
Rochester Union and Advertiser, 1868.
———. May 1907.
Saturday Evening Post. November 14, 1829.

Chapter 4

The Bayfield Bunch, June 17, 2014. http://thebayfieldbunch.com/2014/06/a-correction.html#links.
Kennard, Jim. "Shipwreck Explorers Discover 1850's Schooner in Lake Ontario." December 14, 2009. shipwreckworld.com/articles/shipwreck-explorers-discover-1850s-schooner-lake-ontario.
Niagara Constellation. December 7, 1799.
Palmer, Richard. "Devil's Nose." December 21, 2011. oceantreasures.org/blog/do/tag/devil-s-nose.
Rochester Union and Advertiser.
Upper Canada Gazette. December 21, 1799.

Chapter 5

Driver, Robert J., Jr. *The Confederate Soldiers of Rockbridge, County, Virginia: A Roster.* Jefferson, NC: McFarland and Company, 2016.

findagrave.com.
Laurant, Darrell. "Bible Makes Exodus Back to Confederate Soldier's Lynchburg Home." *News and Advance.* November 30, 2010. http://www.newsadvance.com/news/local/bible-makes-exodus-back-to-confederate-soldier-s-lynchburg-home/article_b70b85fd-cdf6-5888-a4a7-0974bf9263a2.html.
Lynchburg Daily Virginian. January 7, 1889.
Rochester Democrat and Chronicle. May 30, 1954.

Chapter 6

Evans, Ed. "Hamlin CCC/POW Camp History Trail Update." Friends of Hamlin Beach. http://friendsofhamlinbeach.org/cccpow.html.
Rochester History 56, no. 3 (Summer 1994).
Rochester Times Union. August 14, 1944.

Chapter 7

ancestry.com.
Cummings, Amos. *History of the Loomis Gang.* 1877. reprints.longform.org/loomis-gang.
findagrave.com.

Chapter 8

GAR General Order No. 11. http://suvcw.org/logan.
"Waterloo: The Birthplace of Memorial Day." Life in the Finger Lakes. lifeinthefingerlakes.com/waterloo-the-birthplace-of-memorial-day.

Chapter 9

Bastine, Michael, and Mason Winfield. *Iroquois Supernatural: Talking Animals and Medicine People*. Rochester, VT: Bear and Company, 2011.
Citizen (Auburn, NY). February 24, 2012.

Chapter 10

Heritage: The Magazine of the NYS Historical Association 3, no. 2 (November-December 1986).
Merrill, Arch. *The Changing Years*. New York: American Book-Stratford Press, 1967.
———. *The Underground, Freedom's Road, and Other Upstate Tales*. Interlaken, NY: Empire State Books, 1993.
National Park Service. "Erie Canalway: History and Culture." nps.gov/erie/learn/historyculture/index.htm.
Smith, James Hadden, and Hume H. Cole. *History of Livingston County, New York*. Salem, MA: Higginson Book Company, 1997.
stagecoachdays.blogspot.com.

Chapter 11

Askins, Alice. "The Seneca Chief." Geneva Historical Society, November 22, 2013. genevahistoricalsociety.com/transportation/the-seneca-chief.
Courier (Geneva, NY). July 1828.
Geneva Gazette. July 1828, July 1889.
Kennard, Jim. "152-Year-Old Paddle Wheeler Onondaga Located in New York Finger Lake." *Shipwreck World*. August 14, 2012.
Life in the Finger Lakes. lifeinthefingerlakes.com.

Chapter 12

Democrat and Chronicle. January 18, 2014.

———. January 9, 1901.
Mayer, Bonnie. "The Corn Hill Orphanage Fire of 1901." cornhill.org/history-of-corn-hill/corn-hill-orphanage-fire-of-1901.
Rochester History 9 (1947).

Chapter 13

Lyon Wayne Democratic Press. 1861.

Chapter 14

rodserling.com.
"Rod Serling: Submitted for Your Approval, About Rod Serling." PBS. December 29, 2003. pbs.com/wnet/americanmasters/rod-seling-about-rod-serling/702.
Rossen, Jake. "8 Bizarre Facts about Rod Serling and the *Twilight Zone*." Mental Floss, October 8, 2014. mentalfloss.com/article/59288/8-bizarre-facts-about-rod-serling-and-twilight-zone.

Chapter 15

"Catholic Church." Historic Sodus Point. historicsoduspoint.com/buildings/churches/catholic-church.
findagrave.com.
Fox, Rosa. "Lummis Family and Lummisville." *Flash* (Summer 2015). historichuron.org/lummis-family-and-lummisville.

Chapter 16

Civil War Monuments in Waterloo. suvcw.org/ny/monuments/seneca/waterloo.

findagrave.com.
Hannagan, Charley. "Why Is an Upstate NY Historian Trying to Save a Really Old Tree." March 30, 2017. syracuse.com/news/index.ssf/2017/03/upstate_historian_seeks_to_preserve_historic_scythe_tree_linked_to_civil_war.html.
Roadside America. "Scythe Tree." roadsideamerica.com/story/10660.

Chapter 17

Brockport Republic. September 6, 1894.
Brockport Republic Democrat. July 27, 1940.

Chapter 18

Elwell, A.B. *The History of Brockport and Vicinity Happenings.* Brockport, NY, 1956.
Merrill, Arch. *The Ridge: Ontario's Blossom Country.* Rochester, NY: Louis Heindl, 1944.
Rochester Democrat and Chronicle. August 25, 1885.
———. July 7, 1924.
Somerville, Kyle. "The (Re)Creation of Place at Ontario Beach Park." *Rochester History* 75, no. 1 (2013).

Chapter 19

Abbott, Karen. "The Fox Sisters and the Rap on Spiritualism." October 30, 2012. https://www.smithsonianmag.com/history/the-fox-sisters-and-the-rap-on-spiritualism-99663697.
Brooklyn Daily Eagle. March 9, 1893.
Clemens, Chris. "Hydesville Memorial Park and the Fox Sisters." Exploring Upstate, April 14, 2015. https://exploringupstate.com/hydesville-memorial-park-and-the-fox-sisters-newark-ny.
Evening Post (New York). April 27, 1848.

"Hydesville Park History." National Spiritualist Association of Churches. nsac.org/who-we-are/fox-property-history.

Chapter 20

Atlas Obscura. "Willard Asylum for the Chronic Insane." atlasobscura.com/places/willard-asylum-for-the-chronic-insane.
familysearch.com.
findagrave.com.
Home in the Finger Lakes. "Lawrence Mocha." homeinthefingerlakes.com/lawrence-mocha.
———. "Willard Asylum, Ovid, New York." homeinthefingerlakes.com/willard-asylum-ovid-ny.
Inmates of Willard. "The Good News: One Man Is Remembered!" June 14, 2015. https://inmatesofwillard.com/tag/lawrence-mocha.
Ithaca Times. December 23, 2014.
New York Times. December 7, 2007.
———. December 23, 2014.
———. November 28, 2014.
tinytowntimes.com.
willardcemeterymemorialproject.com.
willardsuitcases.com.

About the Author

Patti Unvericht is the author of *Ghosts and Hauntings of the Finger Lakes* (The History Press, 2012) and a native of the Finger Lakes region living in Rochester. She is studying to be a tour guide with the Friends of Mt. Hope Cemetery (Rochester), where she also gives tours. Patti is the mother of two wonderful children: Liesl and Karl. When she isn't writing, she enjoys traveling with her boyfriend Steve and hanging out with their dog Ginger.

Visit us at
www.historypress.com